Always deterritorialize! Or so goes the mantra of recent "accelerationist" theory. Intoxication against intoxication, schizophrenia against schizophrenia, delirium against delirium – the accelerationist tendencies of millennial life are laid bare in this concise volume by the author who first suggested the term. From the historical avant-garde, through Detroit techno and science fiction, to Nick Land and the Cybernetic Cultures Research Unit (CCRU), Benjamin Noys reveals the ideological fantasies of speed. We should dismiss accelerationism for its capitalophilia, he concludes, but preserve it for its extremism: go far, go deep and go negative to get real.
Alexander R. Galloway, author of *The Interface Effect*

The notion that 'the worse, the better' has an obvious appeal to disempowered communists in a time of capitalist crisis. *Malign Velocities* steps in and registers the futurist thrill of those theorists who would arrive at communism via an advanced, high tech capitalism – and registers the often disastrous results of these 'accelerations', which took us more often to Stalinism or neoliberalism than to utopia. Noys's writing is erudite, clear, and coloured by the darkest humour.
Owen Hatherley, author of *Uncommon*

In the midst of a hair-shirt neoliberalism, with growth-rates stagnating and accumulation reliant on ever-deeper dispossession, the sirens of speed are once again luring the advocates of radical theory. *Malign Velocities* diagnoses the moment of 'accelerationism' with exacting lucidity, revisiting prior iterations of the idea of an excessive exit from the clutches of capital – from futurism to cyberpunk – and uncovering these theories' political-

economic unconscious, the accelerationist's fantasy of labour. Noys's book is a model of dialectical critique, combining a sophisticated account of accelerationism's historical conditions of possibility with an incisive verdict about its incapacity to generate strategies adequate to this conjuncture of crisis. *Malign Velocities* succeeds in both being true to the materialist injunction not to tell oneself stories and in weaving an engrossing tale of theory's struggles with the limits and compulsions of capitalism.

Alberto Toscano, Reader in Critical Theory, Goldsmiths, and author of *Fanaticism: On the Uses of an Idea*

Malign Velocities

Accelerationism & Capitalism

Malign Velocities

Accelerationism & Capitalism

Benjamin Noys

Winchester, UK
Washington, USA

First published by Zero Books, 2014
Zero Books is an imprint of John Hunt Publishing Ltd., Laurel House, Station Approach,
Alresford, Hants, SO24 9JH, UK
office1@jhpbooks.net
www.johnhuntpublishing.com
www.zero-books.net

For distributor details and how to order please visit the 'Ordering' section on our website.

Text copyright: Benjamin Noys 2013

ISBN: 978 1 78279 300 7

A CIP catalogue record for this book is available from the British Library.

Design: Lee Nash

Printed and bound by CPI Group (UK) Ltd, Croydon, CR0 4YY

We operate a distinctive and ethical publishing philosophy in all
areas of our business, from our global network of authors to
production and worldwide distribution.

CONTENTS

Acknowledgements

My ongoing conversations with Alberto Toscano have been vital to formulating this book. I have also benefited from discussions with Alexander R. Galloway, Matteo Pasquinelli, Armen Avanessian, John Cunningham, Oxana Timofeeva, Federico Luisetti, Ross Wolfe, Owen Hatherley, Harrison Fluss, Federico Campagna, Sami Khatib, Daniel Spaulding, Daniel Marcus, Steve Shaviro, Andrew Osborne, Jaleh Mansoor, and Anthony Iles. Hilan Bensusan was generous enough to invite me to speak in Brasilia on accelerationism and to guide me around the city. Alex Williams and Nick Srnicek were kind enough to share their pro-accelerationist work with an enemy, and to engage with debate over my arguments. I'd like to thank Eugene Brennan for his close and careful reading of the manuscript. Anindya Bhattachryya helpfully supplied useful soundtrack suggestions. Dean Kenning deserves special thanks for providing the cover image. All errors are, as usual, my own. Above all, my thanks go to Fiona Price, for her support, criticism, and advice.

Chapter 4 draws on material published as 'Speed Machines', in *Nyx* 'Machines' (2012), and Chapter 5 on the article 'Apocalypse, Tendency, Crisis', published in *Mute: Culture and Politics After the Net* 2.15 (2010). I would like to thank the editors of those journals for permission to reuse this work. I want to thank Mark Fisher for inviting me to the 'Accelerationism' event, at Goldsmiths, on 14 September 2010, and for all those who participated in the resulting discussions. I also want to thank Matteo Pasquinelli and Armen Avanessian for inviting me to Berlin for the Accelerationism Symposium on December 14 2013 and for the papers and discussions on that day.

Preface

Speed is a problem. Our lives are too fast, we are subject to the accelerating demand that we innovate more, work more, enjoy more, produce more, and consume more. Hartmut Rosa declares that today we face a 'totalitarian' form of social acceleration.[1] That's one familiar story. I want to tell another, stranger, story here: of those who think we haven't gone fast enough. Instead of rejecting the increasing tempo of capitalist production they argue that we should embrace and accelerate it. We haven't seen anything yet as regards what speed can do. Such a counsel seems to be one of cynicism, suggesting we come to terms with capitalism as a dynamic of increasing value by actively becoming hyper-capitalist subjects. What interests me is a further turn of the screw of this narrative: the only way out of capitalism is to take it further, to follow its lines of flight or deterritorialization to the absolute end, to speed-up beyond the limits of production and so to rupture the limit of capital itself.

To be clear from the start, I don't agree with this story. The core idea of this book originated in the early '90s, when I first encountered the work of Nick Land and the Cybernetic Cultures Research Unit (CCRU) while working on a thesis on Georges Bataille. This work, as I will discuss in Chapter 4, is the one of the most explicit statements of the desire to accelerate beyond capital. Formulated in the language of science-fiction and contemporary theory (particularly the work of Gilles Deleuze and Félix Guattari), Land and the CCRU rigorously abandoned any humanist residues. Land and his colleagues at the University of Warwick strove for a new post-human state beyond any form of the subject, excepting the delirious processes of capital itself. They claimed that the replication and reinforcement of capital's processes of deterritorialization – of flux and flow – would lead to a cybernetic offensive capital could no longer control. Reading

this full-blown accelerationism alongside discussions of the New Right and their aim to 'dissolve' the state led me, at the time, to coin the term 'Deleuzian Thatcherism'.

It was the resurgence of these ideas in the '00s, including the republication of Land's essays,[2] that made me return to these questions and offer a more precise critical description by using the term 'accelerationism'.[3] It turns out that term occurs in Roger Zelazny's sci-fi novel *Lord of Light* (1967), which I'd read. The unconscious, as usual, works in mysterious ways. After my initial critical analysis a new wave of contemporary accelerationism emerged and it was this fact, especially as this took place at a time of capitalist crisis, that led me to write this book.

My aim is not to offer an exhaustive account of accelerationism, but rather to choose certain moments at which it emerges as a political and cultural strategy. In the Introduction I begin with the theorization of accelerationism by a small group of French theorists in the early to mid-1970s. This brief moment of theoretical excess is, I will argue, a paradoxical attempt to articulate a path beyond a capitalism that seems to have absorbed and recuperated all opposition. It will provide the key which will unlock the different historical moments of acceleration that I then track. Starting with Italian Futurism, I proceed through Communist accelerationism following the Russian Revolution, to fantasies of integration with the machine, the Cyberpunk Phuturism of the '90s and '00s, the apocalyptic accelerationism of the post-2008 moment of crisis, and the negative form of terminal accelerationism. In the final chapter I return to the 1920s and 1930s to restage the debate around accelerationism through the encounter between Walter Benjamin and Bertolt Brecht. This scene condenses the problem of acceleration and the production of the new. In my conclusion I want to suggest a way out of the impasse, which doesn't simply counter acceleration with a desire to slow down.

As this is a work written out of the sense of the difficulty of

defeating accelerationism, I don't hope to write its epitaph here. I can't deny the appeal of accelerationism, particularly as an aesthetic. What I want to do is suggest some reasons for the *attraction* that accelerationism exerts, particularly as it appears as such a counter-intuitive and defeatist strategy. I'll argue that this attraction relies on the ways in which accelerationism takes-up labor under capitalism as site of extreme and perverse enjoyment. The use by accelerationists of the concept of *jouissance* – that French word used to refer to an enjoyment so intense it is indistinguishable from pain, a kind of masochism – is the sign of this. While accelerationism wants to accelerate beyond labor, in doing so it pays attention to the misery and joys of labor as an experience. If we are forced to labor, or consigned to the other hell of unemployment, then accelerationism tries to welcome and immerse us in this inhuman experience. While this fails as a political strategy it tells us much about the impossible experience of labor under capitalism. We are often told labor, or at least 'traditional labor', is over; the very excesses of accelerationism indicate that labor is still a problem that we have not solved. That I think the accelerationist solution of speeding through labor is false will become evident. This does not, however, remove the problem itself.

Benjamin Noys
Bognor Regis, 2014

Introduction:
'Accelerate the Process'

Don't start from the good old things but the bad new ones.

Bertolt Brecht

The Bad New

I want to begin with the moment when the strategy of accelerating through and beyond capitalism was first explicitly theorized. This took place in France in the early to mid-1970s with three books, each appropriately trying to outdo and out-accelerate the other in the attempt to give this strategy its most provocative form. It is these works that frame the debate concerning acceleration and which probe the tense relation between strategies of acceleration and the solvent forces of capitalism.

The first is Gilles Deleuze and Félix Guattari's *Anti-Oedipus: Capitalism and Schizophrenia* (1972), which, as its title suggests, was devoted to a scathing critique of psychoanalysis for confining the force of desire within the Oedipal grid. The ambitions of the book, as its subtitle indicates, went far beyond this. Deleuze and Guattari reevaluated schizophrenia as the signature disorder of contemporary capitalism, arguing that the breakdowns of the schizophrenic were failed attempts to break *through* the limits of capitalism. Capitalism was unique for unleashing the forces of deterritorialization and decoding that other social forms tried to constrain and code. This release was, however, always provisional on a reterritorialization that dragged desire back into the family and the Oedipal matrix, recoding what it had decoded.

Deleuze and Guattari's strategy for revolution was posed in a series of rhetorical questions:

But which is the revolutionary path? Is there one? – To withdraw from the world market, as Samir Amin advises Third World Countries to do, in a curious revival of the fascist 'economic solution'? Or might it be to go in the opposite direction? To go further still, that is, in the movement of the market, of decoding and deterritorialization? For perhaps the flows are not yet deterritorialized enough, not decoded enough, from the viewpoint of a theory and practice of a highly schizophrenic character. Not to withdraw from the process, but to go further, to 'accelerate the process,' as Nietzsche put it: in this matter, the truth is that we haven't seen anything yet.[1]

It is obvious that if we follow Samir Amin's suggestion that countries delink from capitalism we are at the risk being chided with incipient fascism. Instead, we have to follow Deleuze and Guattari's Nietzschean preference to 'accelerate the process'. To break the limit of capital requires further deterritorialization and decoding, beyond the constraints of the Oedipal family and of capitalist economy. This leads to the new figure of the 'schizo', who is no longer the 'limp rag' of the schizophrenic locked in the asylum but a kind of relay for all the uncontainable liquid and accelerating flows of deterritorialization; in Nietzsche's 'schizo' delirium he announced 'I am all the names of history'.[2]

No doubt this is only one extreme moment of a provocative work, which also offers other pathways to analyse the opaque and inertial forms of capital. That said, the recommendation that we reach absolute deterritorialization by accelerating the tendencies of capitalism is explicit enough. Of course the aim of such acceleration is not to reinforce capitalism but rather to generate its meltdown. Marx and Engels, in *The Communist Manifesto* (1848), used the metaphor of capital as the 'sorcerer's apprentice', unleashing forces it cannot control.[3] Deleuze and Guattari stand in this lineage, pushing Marx along the line of hard-edged excess that ruins all values, including the 'value' that

is the core function of capitalism itself. This is a metaphysics of production as desiring-production, which can trace and exceed capitalist forces of production.

In reply, Jean-François Lyotard argued that Deleuze and Guattari hadn't gone far enough. Their celebration of desire still supposed that it formed some kind of exterior force that capitalism was parasitical to, and which we could turn to as an alternative. Instead, Lyotard's *Libidinal Economy* (1974) insisted there was only *one* libidinal economy: the libidinal economy of capitalism itself. We cannot find an 'innocent' schizo desire, but instead have only the desire of capitalism to work with. In what is perhaps the most notorious accelerationist statement of all Lyotard did not shy away from the implications of his position:

> the English unemployed did not have to become workers to survive, they – hang on tight and spit on me – *enjoyed* the hysterical, masochistic, whatever exhaustion it was of *hanging on* in the mines, in the foundries, in the factories, in hell, they enjoyed it, enjoyed the mad destruction of their organic body which was indeed imposed upon them, they enjoyed the decomposition of their personal identity, the identity that the peasant tradition had constructed for them, enjoyed the disso-lutions of their families and villages, and enjoyed the new monstrous *anonymity* of the suburbs and the pubs in morning and evening.[4]

Lyotard denies the kind of left politics that would insist that the worker suffers alienation in their separation from their community, their body, and the organic. Instead Lyotard suggests that the worker experiences *jouissance*, a masochistic pleasure, in the imposed 'mad destruction' of their body. Unsurprisingly, Lyotard's remark lost him most of his friends on the left, and even he would later refer to *Libidinal Economy* as his 'evil book'.[5]

3

In contrast to Deleuze and Guattari's reworking of Marx's 'hidden abode of production' as forces of desire, Lyotard remains on the surface. His is a metaphysics of credit and speculation, in which value is generated from the shifting relations of trade and exchange that accelerate beyond the constraints of actual production. This accounts for Lyotard's weird promotion of the doctrine of mercantilism – as articulated in France in the seventeenth and eighteenth centuries, this is an economic doctrine that aims to control foreign trade in order to secure a positive balance of trade. In Lyotard's hands this doctrine is retooled as a zero-sum game of looting that reveals capitalist libido as the obsession with currency as intensity.

Jean Baudrillard's *Symbolic Exchange and Death* (1976) would criticize both Lyotard *and* Deleuze and Guattari for their nostalgic attachment to desire and the libidinal as oppositional forces. Only 'death, and death alone' incarnated a reversible function that could overturn the omnivorous coding capitalism imposed.[6] What Baudrillard found in death was a 'symbolic' challenge that exterminated value by returning to a pre-capitalist economy of the challenge of the gift, which was now linked to exceeding the forces of capital by 'magical' reversal.

Baudrillard, however, takes a distance from accelerationism by disputing the metaphysics of production that underlay Marxism and these dissident currents. In *The Mirror of Production* (1973) he had already critiqued 'an unbridled romanticism of productivity'.[7] For Baudrillard what accelerated was not some force of libidinal flux or flow, but a catastrophic and entropic negativity that floods back into the system causing it to implode – the result is a *terminal* accelerationism.

This is an accelerationist metaphysics of inflation – not simply capitalist inflation, which hollows out the function of money but also a superior symbolic exchange that insinuates itself within capitalist exchange and accelerates this process. While Baudrillard does not celebrate production or the circulation of

libido, he tracks the inflationary bubbles of money as signs of capitalism evacuating itself of meaning and value.

It is an irony that Lyotard, responding to earlier versions of Baudrillard's argument, had already suggested that: '[t]here is as much libidinal intensity in capitalist exchange as in the alleged "symbolic" exchange'.[8] Mocking Baudrillard's anthropological turn to the 'primitive' Lyotard stated there was no 'good hippy' to practice symbolic exchange, only 'the desire of capital'.[9] What Lyotard suggested was that even death was no way out of capitalism, which was the only game in town. The result was that Baudrillard's faith in another principle of exchange was misguided, as capitalism could absorb and parasite on any symbolic exchange.

In this dizzying theoretical spiral we can see a common accusation: each accuses the other of not really accepting that they are fully immersed in capital and trying to hold on to a point of escape: desire, libido, death. Each also embodies a particular moment of capital: production, credit, and inflation. The result is that each intensifies a politics of radical immanence, of immersion in capital to the point where any way to distinguish a radical strategy from the strategy of capital seems to disappear completely.

The Destructive Element

In Joseph Conrad's novel Lord Jim (1900), the character Stein gives some (for Conrad) characteristically enigmatic advice:

A man that is born falls into a dream like a man who falls into the sea. If he tries to climb out into the air as inexperienced people endeavour to do, he drowns – nicht wahr? ... No! I tell you! The way is to the destructive element submit yourself, and with the exertions of your hands and feet in the water make the deep, deep sea keep you up. So if you ask me – how to be?

His answer: 'In the destructive element immerse.'[10] These theoretical accelerationists take Stein's advice to heart. We fall into capitalism and, rather than try to climb out, we have to submit and swim with the capitalist current.

This reaction could be seen as a result of the defeat of the hopes inspired by the revolutionary events in France, which are condensed in the signifier 'May '68'. At the time Deleuze and Guattari, Lyotard, and Baudrillard were writing this defeat was not evident, and many others were working throughout the 1970s to sustain and radicalize the struggles unleashed in '68. Those energies would fade into the reactionary 1980s, and then the accelerationist positions of Deleuze and Guattari, Lyotard, and Baudrillard would become prescient. Their positions registered the durability of capitalism and its ability to spread its domination, often by recuperating forms of struggle. The totalizing effects of capital would appear capable of rolling-up revolutionary advance, making the search for a revolutionary subject outside of capital superfluous. While Deleuze and Guattari would maintain faith in new revolutionary subjectivities – the 'schizo', and what they would later call 'minor' becomings – Lyotard and Baudrillard would more firmly embrace disenchantment.

Far from simply being signs of the times these accelerationist formulations gained resonance as predications of the bad days to come. They would find more purchase in the 'polar night' of the 1980s. At that point rising fears of nuclear destruction, a glaciated Cold War, and the beginnings of the neoliberal counteroffensive, offered a felt experience of closed, if not terminal, horizons. Being a teenager at that time was to live in an atmosphere of ambient dread, summed-up for me in viewing the traumatic BBC post nuclear-attack film *Threads* (1984) and the paranoia of Troy Kennedy Martin's *Edge of Darkness* (1985). It has recently been revealed that Whitehall planners had formulated a nuclear wargame scenario with the suitably chilling codename Winter-Cimex

83. My later reading of Baudrillard's *In the Shadow of the Silent Majorities*, published in the Semiotext(e) Foreign Agents series of little black-books, produced an immediate sense of recognition of this mood. Baudrillard's implosive theorization would be truer to the inertial nature of capitalism, disputing accelerationist images of ever-expansive capitalism.

The reason theoretical accelerationism caught this mood was precisely because it was formulated in the mid-1970s, at the beginning of the long capitalist downturn. These hymns to the excessive powers of capitalism were articulated in the face of crisis – the 'oil crisis', the abandonment of the gold standard, and the crisis of productivity, as well as the political crisis of legitimation (Watergate, etc.). In 1972 the Club of Rome published *The Limits to Growth*, which used computer modelling to argue that capitalism was undermining the material bases of its own 'success'. So, in a strange way this theoretical moment of accelerationism seemed to be running against the current of capitalism entering a period of stagnation, deceleration, and decline. On the other hand, however, it appeared predictive of the sudden 'acceleration' of cybernetic and financial forces that would form the basis for neoliberalism, signalled by the election of Margaret Thatcher in the UK in 1979 and the election of Ronald Reagan in the US in 1980. The fact that, in particular, Deleuze and Guattari's term 'deterritorialization' would find a fecund future in being used to describe neoliberal capital is one sign of this.

These models formulate, in advance, the common sense of the '90s that 'there is no alternative' (TINA). If we follow the career of accelerationism across these moments we see it engaging and reengaging with the closing of the horizon of capitalism. It offers a way of understanding the continuing penetration of capitalism – horizontally, across the world and vertically, down into the very pores of life – and also, of celebrating this as the imminent sign of transcendence and victory. Our immersion in immanence is required to speed the process to the moment of transcendence

as threshold. In this way immanence is paired with a (deferred) transcendence and defeat is turned into victory. At the same time defeat is registered by these forms of theoretical accelerationism in the form of ecstatic suffering, of *jouissance*, experienced in our deepening immersion.

Heretics of Marx

This theoretical moment involved a strange fusion of Marx and Nietzsche. It took from Nietzsche the apocalyptic desire to 'break the world in two', and the need to push through to complete the nihilism, the collapse of values, that afflicts our culture. Nietzsche did not decry the collapse of values, but saw these ruins as the possibility to move beyond the limits of Western culture.

This would be fused with Marx's contention that history advanced by the bad side, which welcomed the solvent effects of capitalism in dissolving the old world.[11] The result was a Nietzschean Marx, a Marx of force and destruction. In 1859 we find Marx hymning the productive powers of force:

No social order is ever destroyed before all the productive forces for which it is sufficient have been developed, and new superior relations of production never replace older ones before the material conditions for their existence have matured within the framework of the old society.[12]

In this modelling we have a teleology – the linear passage through different modes of production in which communism solves the riddle of history and promises a superior mode of productivity, one not subject to the antagonism of capitalism.

Perhaps the most controversial moment of the 'Nietzschean Marx' is the series of articles he wrote on India. In his 1853 article 'The Future Results of the British Rule in India' Marx stressed how British colonialism would disrupt the 'stagnation' of India and appears to welcome the violence of colonialism, the arrival of

industry, and the railways, as a necessary shattering of the old ways. Even this is, however, equivocal. Marx notes that bourgeois 'progress' always involves 'dragging individuals and peoples through blood and dirt', and that British colonialism has hardly brought anything beyond destruction.[13] For Marx it would only be through social revolution that these 'developments' could be appropriated to forge a just society.[14]

While there is a teleological Marx of development and production, Marx also insisted that capitalism does not *automatically* lead to communism. In *The Communist Manifesto* Marx and Engels argued that capitalist crisis posed the *choice* between the 'common ruin of the contending classes' and 'the revolutionary reconstitution of society at large'.[15] Marx welcomed worker struggles to reduce the working day and to struggle against the despotism of the factory; he did not argue that it would be better if factory conditions got worse so workers would be forced into revolt. The fact that history advances by the bad side does not mean we should celebrate the 'bad side', but rather recognize this is the ground on which we struggle, which must be negated to constitute a new and just social order.

The theoretical accelerationists try to break this dialectic of redemption by emphasizing only the violent moment of creative destruction. In place of the just society generated through struggle, it is acceleration that becomes the vehicle of disenchanted redemption. This makes them heretics of Marx. While the classic theoretical accelerationists often adopt Nietzschean themes of contingency and chance, in terms of acceleration they tend to reinstate the most teleological forms of Marxism. To resolve this problem accelerationism projects contingency on to capitalism, which becomes an anti-teleological, or 'acephalic' (headless) social form. In making this projection the accelerationists take as fact capitalism's fundamental fantasy of self-engendering production. They are an archetypal instance of the fetishists of capital.

Certainly such a fantasy of self-engendering production is present in Marx, as we have seen. I think that the critique of this fantasy is a fundamental necessity. While we can certainly only begin to construct a just society on the ground of what exists this does not entail accepting all that exists or accepting what exists as it is given. This is a crucial political question: how can we create change out of the 'bad new' without replicating it? Of course, the accelerationist answer is by replicating more because replication will lead to the 'implosion' of capital. Replication, however, reinforces the dominance of capitalism, leaving us within capital as the unsurpassable horizon of our time.

The Road of Excess

It might be easy to dismiss theoretical accelerationism as a malady of those who take theory too far, spinning-off into abstract speculation. In fact, the very point of accelerationism is going too far, and the revelling and enjoyment engendered by this immersion and excess. They push into the domain of abstraction and speculation which, with the financial crisis, is evidently the space of our existence. I am sceptical that such a 'road of excess' will, in William Blake's words, lead 'to the palace of wisdom'. It does, however, lead us to think what this excess and abstraction might register. If accelerationism is not the revolutionary path it may be the path that records, in exaggerated and hyperbolic form, some of the seismic shifts of capitalist accumulation from the 1970s to the present.

What accelerationism registers in particular are two contra-dictory trendlines: the first is that of the real deceleration of capitalism, in terms of a declining rate of return on capital investment, which has led to a massive switching into debt. The second is the acceleration of financialization, driven by the new computing and cybernetic technologies, which themselves create an image of dynamism. Of course, this 'contradiction' of deceler-ation and acceleration speaks to a dual dynamic as capitalism

tries to restart processes of accumulation by acceleration. The financial crisis that began in 2008 brought this contradiction to the point of collapse.

It is in this double dynamic that accelerationism finds its theorization, answering deceleration with the promise of a new acceleration, driven by faith in new productive forces that come online and disrupt the ideological humanism that tends to be capitalism's default ideology. In capitalism we are treated as free agents, although always free to choose within the terms set by the market. Accelerationists reject this 'humanism' by embracing dehumanization. They take utterly seriously the Marxist argument concerning the dehumanizing aspects of capitalism and they also take seriously those ideologues of the market who try to dehumanize us into 'mere' market-machines. This accounts for the instability of accelerationism, which is poised on this faultline.

It also speaks to the position of labor within capitalism: at once necessary, as Marx noted, to the production of value, while also constantly squeezed out by machines and unemployment. For Marx capitalism is 'the moving contradiction', which 'presses to reduce labor time to a minimum, while it posits labor time, on the other side, as sole measure and source of wealth.'[16] This contradiction has only become more and more striking over the last forty or so years. The place of labor has shifted, at least in countries like the UK and US, from manufacturing to the so-called service economy (although this shift should not be overstated). It has also been displaced geographically and displaced in form – dispersed beyond the concentrated forms that it once held, or seemed to hold. At the same time, many of us work longer and harder. The relief that technology was supposed to bring from labor merely leaves less labor doing more work. No longer, as in Marx's day, are we all chained to factory machines, but now some of us carry our chains around with us, in the form of laptops and phones.

My suggestion is that accelerationism tries to reengage with the problem of labor as this impossible and masochistic experience by reintegrating labor *into* the machine. In what follows, we will see this fantasy of integration, the 'man-machine' (note the gendering), that might at once save and transcend the laboring body. This will take various forms, at once radically dystopian and radically utopian. Rather than taking this as a solution, I will argue it is a *symptom*. If we take accelerationism critically then we can use it to gauge the mutations of labor and its resistance to integration within capitalism and the machine – including sabotage, strikes, and more enigmatic forms of passive resistance. The stress of theoretical accelerationism on our immersion in capitalism will prove central to unlocking the various cultural and historical moments I will trace in this book. It is the extremity of accelerationism makes it the most useful diagnostic tool. It will also allow us to try and break the appeal of acceleration.

I

War Machines

To visit Gabriele D'Annunzio's villa and garden at Gardone Riviera on Lake Garda is to experience the commemoration of speed as the essential sign of modernity. This is speed vectored through that other sign of modernity: mechanized warfare. Beyond his poetry, the villa and garden are D'Annunzio's truly prefigurative artworks of the twentieth century. The *Vittoriale degli italiani* (The Shrine of Italian Victories), as the estate is named, is a remarkable and disturbing testament to the 'manmachine' of D'Annunzio's protofuturist and protofascist vision. It contains all the 'speed machines' that embody this aesthetics of acceleration and war. There is the *Motoscafo Armato Silurante* MAS-96 anti-submarine motorboat D'Annunzio captained, and the name of which he détourned into the Latin motto *Memento audere semper* – 'remember always to dare'). The SVA-5 aeroplane in which he flew to drop propaganda leaflets and bombs in the '*il Volo su Vienna*' ('Flight over Vienna') as squadron leader of the 'La Serenissima' 87th fighter-squadron on 9 August 1918. The most striking machine is the warship Puglia, donated by the Italian government and now embedded into the hillside.

The phallic ship thrusting from the hillside seems to embody exactly the masculine and protofascist mastery over nature by technology and acceleration. D'Annunzio wrote that the prow of a warship was 'a monstrous phallic elongation'.[1] It embodies what Paul Virilio, writing of the Italian Futurist F.T. Marinetti, called the '*inhuman type*': 'an animal body that disappears in the superpower of a metallic body able to annihilate time and space through its dynamic performances.'[2] D'Annunzio's personal motto '*per non dormire*' ('In order not to sleep') captures perfectly, in advance, this vectoring of human will into a mechanized

acceleration that displaces any organic need. It might also stand as the motto for contemporary capitalism, which, as Jonathan Crary has noted, declares war on sleep as one of the few residual and non-productive human activities.[3]

The ship, however, is somehow integrated into nature, in a strange fusion that accelerates the forces of nature as the vessel thrusts itself from the hillside into the lake. To stand on the deck is to experience a vertiginous toppling of the frozen moment of launching. The fact that the other various machines and devices of speed and destruction are placed in a house and garden offers an incongruous experience that estranges both the natural and the technological. This techno-pastoral figures the desire to infuse the forces of technology into nature and to give life to technology through the integration of nature. What is crucial is the link between technological speed and the dynamic and vital will of the 'animal' or natural body.

In this chapter I want to consider the Italian Futurist celebration of speed and their attempt to harness the forces of velocity and acceleration as the Ur-form of accelerationism. The Futurist's cult of war, their misogyny, and their alliance with fascism, make them the symbolically toxic avant-garde. My aim is not to redeem the irredeemable, or to use them to convict accelerationism in advance. Instead, I want to explore how the Futurists try to grasp and integrate forces of production that appear as forces of *destruction*. This involves strange integrations and displacements, as the Futurists try to fuse and infuse mechanical bodies with vital forces and accelerate these new fused forces towards a threshold of destruction and rebirth.

Cruel Razors of Velocity
The Italian Futurists fully inhabited the cult of speed predicted by D'Annunzio. Point Four of 'The Founding and Manifesto of Futurism' (1909), written by Marinetti, announces:

We affirm that the beauty of the world has been enriched by a new form of beauty: the beauty of speed. A racing car with a hood that glistens with large pipes resembling a serpent with explosive breath ... a roaring automobile that seems to ride on grapeshot – that is more beautiful than the *Victory of Samothrace*.[4]

In Point Eight the Futurists go on to declare that 'we have already created velocity which is eternal and omnipresent', and in Point Nine to make clear the importance of military speed (and misogyny): 'We intend to glorify war – the only hygiene of the world – militarism, patriotism, the destructive gesture of anarchists, beautiful ideas worth dying for, and contempt for woman.'[5]

The contempt for woman indicates the usual armoured trope of erecting the hard, phallic and mechanized male body over and against the feminized: soft, liquid, and organic. In response the Futurist 'feminist' Valentine De Saint-Point wrote the 'Manifesto of Futurist Woman' (1912), which suggested women were equal to men – equal in terms of meriting the same disdain.[6] After this amusingly anti-humanist opening the argument falls back into arguing that both men *and* women needed more virility, and that both should take the 'brute' as their model. The solution to misogyny is to join an equality of brutality, confirming the phallic hardness of the machine as destination for both genders.

In a similar fashion Marinetti's misogyny also opens on to a general anti-humanism – the cult of speed is one that bursts apart the limits of the human. Marinetti declared: 'Those who are weak and sick [will be], crushed, crumbled, pulverized by the relentless wheels of intense civilization. The green beards of moss-grown streets in the provinces will be shaved clean by the cruel razors of velocity.'[7] The only survival is elective surgery by 'the cruel razors of velocity' that will provide the 'clean' speed to transform the human body into a new individual war-machine.

The Futurists try to perform what Fredric Jameson calls 'a virtual cooptation of the machine, a homeopathic expropriation of its alienated dynamism.'[8] This virtual co-optation of dynamism by means of war runs through to the very end of Futurism. In 1941 Marinetti composed the manifesto of 'Qualitative Imaginative Futurist Mathematics', with the Futurist poet Pino Masanta and the renegade mathematician Marcello Puma.[9] Puma was a student of quantum mechanics and the diffusion patterns of infectious diseases. This new 'antistatic antilogical antiphilosophical mathematics' offered modes of acceleration that are non-linear. The Futurist embrace of chance and randomness meant that they could imagine a 'poetic geometry' in which the river Nile could be redirected to turn back on itself, which suggests that Futurist accelerationism is not simply a teleological movement forward.

Yet, this is still a deeply dubious political mathematics, which plays off the disruptive force of the Futurists against their political enemies. The manifesto celebrates the battle of 15 April 1919, when Futurists and war veterans assaulted a communist rally on the Via dei Mercanti in Milan, before going on to burn down the headquarters of the Socialist Party's newspaper *Avanti!*:

> Calculate the clear sum of revolutionary Victory obtained in Milan the 15th of April 1919 (the Battle of Via dei Mercanti) by means of 50 Futurist poets 100 Arditi 50 early Fascist squadristi and 300 students from the Polytechnical Institute + the political genius of Mussolini + bold aeropoetic imagination of Marinetti + Ferruccio Vecchi in order to defeat 100,000 socialists-communists routed because imbued with pacifism and hence frightened by pistols multiplied a hundredfold by patriotic courage.[10]

Marinetti and Puma's calculus appears objective, but it rests success in combat on the qualitative value of 'great men'. The

contingent allows the infusion of the leader into the 'objective' array of mechanical forces.

This Futurist mathematics, according to Jeffrey T. Schnapp, engages with the new statistics generated by capitalist society by trying to overload the circuits of accumulative linear mathematics with a 'statistical sublime'.[11] In the case of their machinic integration we can see how the attempt at virtual co-optation of dynamism also tries to inhabit and overload the technological forces Futurism lauds. This suggests that Futurism isn't simply the celebration of technology and war, but a reworking or struggle to push acceleration into new forms. Obviously the dominant forms of Italian Futurism compromised or celebrated the Fascist 'solution', while also remaining in a complicated and marginal position to Fascist modernization. What the Futurists highlight is that accelerationism is always an intervention or a selection of forces, particularly structured by the need to integrate labor within a new 'mechanical' configuration.

In the Lunapark

In the Epilogue to his famous essay 'The Work of Art in the Age of Mechanical Reproduction' (1936) Walter Benjamin condemned the Futurists for aestheticizing war, in which 'we experience [our] own destruction as an aesthetic pleasure of the first order.'[12] While this has become the accepted diagnosis of the Futurists, Benjamin goes on to add a caveat: we can accept the Futurist diagnosis if we understand their aestheticization of war as the result of the impeding of the 'natural' use of the productive forces. The Futurists aestheticize the destructive turn of the productive forces because they cannot truly grasp the possibility of redeploying these forces.

Benjamin's brief suggestion returns to his short work 'To the Planetarium', contained in his book *One-Way Street* (1928). There he argued that the First World War was 'an attempt at new and unprecedented commingling with the cosmic powers.'[13] While

science seems to have disenchanted the stars we cannot simply evade these cosmic powers, which are retranslated into technological forces. The war presents the equivocal site of released and intoxicating forces of destruction:

> Human multitudes, gases, electrical forces were hurled into the open country, high-frequency currents coursed through the landscape, new constellations rose in the sky, aerial space and ocean depths thundered with propellers, and everywhere sacrificial shafts were dug in Mother Earth. (103–4)

In Benjamin's quasi-mystical reading this is an 'immense wooing of the cosmos' carried out via 'the spirit of technology' (104). The resulting 'bloodbath' was due to these cosmic forces being subject to profit, i.e. to capitalism.

This does not imply these forces should be abandoned. Benjamin argues that we reconfigure the relation between mastery and technology. No longer should humans master nature, but humans need to master the *relation* between us and nature. The intoxication of these cosmic powers has gone astray, and this turns on the question of speed:

> One need recall only the experience of velocities by virtue of which mankind is now preparing to embark on incalculable journeys into the interior of time, to encounter there rhythms from which the sick shall draw strength as they did earlier on high mountains or on the shores of southern seas. The 'Lunaparks' are a prefiguration of sanatoria. (104)

'Lunaparks' was an early name for what we now call amusement parks, and the first park to use this name was in Coney Island, New York in 1907. Benjamin's suggestion is that these parks – with their rollercoasters and other rides – form a kind of homeopathic or therapeutic intoxication or acceleration, which will

allow us to cure the tubercular sickness of technology. Intoxication is played against intoxication.

The result is an embrace to wrest technology, as second nature, into a new configuration:

> In the nights of annihilation of the last war the frame of mankind was shaken by a feeling that resembled the bliss of the epileptic. And the revolts that followed it were the first attempt of mankind to bring the new body under its control. The power of the proletariat is the measure of its convalescence. If it is not gripped to the very marrow by the discipline of this power, no pacifist polemics will save it. Living substance conquers the frenzy of destruction only in the ecstasy of procreation [*Rausche der Zeugung*]. (104)

In Benjamin's strange cosmic phantasmagoria, which he will later problematize or rescind (as we will see in Chapter 7), the forces of annihilation produce a new intoxication, a new collective and personal body that we have to master – a 'rush' [*Rausche*].

Despite their extreme political differences we can see a convergence between the Futurists and Benjamin on this equivocal ground of the mastery of technologies of acceleration. While Benjamin banks on communist revolt and the Futurists favour the new 'discipline' of Fascism, they both suggest a utopian possibility of the collective mastery of acceleration. What they attend to is the integration and acceleration of intoxicating and ecstatic forces. There is no turning back, they imply. What needs more probing is the form and nature of these forces.

Mechanical Asceticism

The Futurists operated an aesthetic of acceleration that was not only predicated on war, but also on the industrial revolution. The energies they aimed to tap were, in fact, positioned at the

confluence between industry and warfare. Yet, there was something odd and even anachronistic about this attempt. In his autobiography the English Vorticist Wyndham Lewis reports his encounter with the Futurist Marinetti. When Marinetti tried to enlist Lewis as a Futurist, Lewis replied in a typically racist and acerbic fashion:

> 'Not too bad,' said I. 'It has its points. But you Wops insist too much on the Machine. You're always on about these driving-belts, you are always exploding about internal combustion. We've had machines here in England for a donkey's years. They're no novelty to *us*.'[14]

Putting aside the racial sneer, Lewis's point invokes another experience of the machine – one that isn't about the shock of modernity but rather the integration of the machine in everyday life.

Marinetti's reply to Lewis is, precisely, predicated on acceleration: 'You have never understood your machines! You have never known the *ivresse* of travelling at a kilometre a minute. Have you ever travelled a kilometre a minute?' Lewis's reply is: "Never.' I shook my head energetically. 'Never. I loathe anything that goes too quickly. If it goes too quickly, it is not there."[15] Lewis invokes, as he often would, the need for sharp division, which is opposed to the blurring caused by speed. His invocation of the experience of the machine in Britain, however, suggests a complex relationship between speed, machines, and labor, which is not limited to the mechanization of warfare.

It is Lyotard who closely links the experience of the avant-garde with the experience of the worker. Reflecting on his own notorious invocation of the worker's experience of *jouissance* in factory labor Lyotard later commented that: '[T]he point was to convey that there is in the hardest working-class condition an impressive contribution that easily matches, and perhaps

exceeds, the adventures of poets, painters, musicians, mathematicians, physicists, and the boldest tinkerers and tamperers.'[16] The imposed demand on the worker to construct a new body, a new sensorium, and new sensibility matched or exceeded the experiments of the avant-garde in the creation of 'man-machines'.

Lyotard traces the energies of the integration of labor and the machine over a longer time-span, in which the avant-garde, ironically, features as a late arrival. The workers of the nineteenth century had already gone beyond the sensory limit of the body and, in Lyotard's controversial addition, *enjoyed* that experience. Lyotard's stress is two-fold. First, that we shouldn't dismiss the experience of peasants become workers as that of simple victims who suffered passively. There was an *active* engagement with these new possibilities of the augmented and expanded body. His second point is that this engagement creates a new mode of experience and, even, of ethics. The workers practiced, long before the avant-gardes, a 'mechanical asceticism', by holding on in a place in which it had seemed impossible to do so.

The result was the birth of 'a new sensibility made up of little strange montages.' (15) In pugnacious style Lyotard has little time for those who don't accept the experience of workers as an ecstatic one: '"*Jouissance*." The French think it means the euphoria that follows a meal washed down with Beaujolais.' (18) Rejecting this sanitization of masochistic pleasure Lyotard, like Lewis, points to the longer form of the worker's engagement with the machine. This is implicit in the forms of Futurism, which flirted with anarchism and syndicalism, as well as Fascism. The difficulty of accelerationism, which will thread its way through this book, is its attempt to solve this suffering of labor by integrating labor into the machine. If war, for all its destructive power, can be flipped into heroism, labor remains more resistant.

Lyotard's mechanical sublime, which he will later translate into a tragic register by taking the Holocaust as his model,

indicates, at this point, an excess that is utopian. The rupture is one that places the worker at the center, on the condition they disappear into an aesthetic of forces. Such a model speaks to the Futurist's 'statistical sublime', which was their attempt to map an accelerated access that exceeded the forces of structure and control. For Lyotard this sublime moment would mark his departure from the left, and the Futurists were even more politically dubious. It seems that the desire to transgress leftist 'pieties' leads to the embrace of the sublime, and an embrace which restores that trope to its conservative roots. Excess is not necessarily good.

Unknown Soldiers

Paul Virilio draws out a whole genealogy of the celebrants of speed: 'whether it's the drop-outs, the beat generation, automobile drivers, migrant workers, tourists, Olympic champions or travel agents, the military-industrial democracies have made every social category, without distinction, into *unknown soldiers of the order of speeds*.[17] The Futurists are the pioneers of this new order. The brevity of their own moment, disappearing into a war which killed several of their leading members before a brief interwar revival, is one sign of their own desire to accelerate into the future. Their own lived experience of avant-garde time was predicated on speed and obsolescence. In the Founding Manifesto Marinetti announced that 'others who are younger and stronger will throw us in the wastebasket, like useless manuscripts. — We want it to happen!'[18]

This logic of obsolescence speaks not only to the frantic emergence and extinction of the avant-garde, with each trying to accelerate beyond the other, but also to the experience of labor. The worn-out bodies of factory workers, or other laborers, are retired or dumped to be replaced by new 'younger and stronger' bodies. In a way Futurism zeros in on this logic of replacement – first, in its attempt to replace the soft and decadent bourgeois

body with a new hardened Futurist body, then with the discarding of that body as it wears out. This model of finitude implies that acceleration and technology do not smoothly unfold in a linear teleology that delivers us beyond the limits of labor. Instead we seem to remain at this limit as a point of struggle and contradiction.

The aim of my discussion of Futurism as the crucible of accelerationism has been to explore this limit. On one hand, Futurism appears mimetic and apologetic of the acceleration of capitalist technology, if not wanting to re-order this in Fascist forms. On the other hand, the non-linear and destructive moments of Futurism threaten to collapse this ideological programme and put accelerationism into question. That I don't think this questioning goes far enough should be obvious. The reappearance of acceleration today, however, suggests the equivocal attraction of an avant-garde that promised an intervention which could grasp, or attempt to grasp, technological forces. Our current moment, as we will go on to see, lacks this hope and tries to recover it from the past. The irony is that accelerationism, which is relentlessly directed toward the future, turns out to be nostalgic. This irony will recur. The nostalgia of accelerationism suggests, I think, the difficulty in engaging with the problem of labor and with disengaging from the existent lines of flight that determine acceleration. The revenge of replication is one which haunts the accelerationist pursuit of the sublime, whether in warfare or in industrial production. The Futurists did not predict the retooled future of technology integrated with man they intended, but rather the brutal history of displacements and reworkings that fall back within the forms of value. In trying to escape to some statistical sublime, they fall back into the value sublime.

2

Leaps! Leaps! Leaps!: Communist Accelerationism

The Revolution has cut time in half.

Trotsky, *Literature and Revolution* (1924)

Robin Blackburn reports a story told to him when he worked for the Cuban Ministry of Soviet Trade in the 1960s. At an economic conference convened by the then-President Osvaldo Dorticós there was a discussion of a particular plan for a sector of the economy. One adviser argued that the aim must be to produce the maximum output for the minimum effort and expense. Dorticós emphatically disagreed: 'This is not the revolutionary way,' he insisted, 'instead we aim to achieve the maximum of output with the maximum forces (*fuerzas*).'[1] I want to explore this attitude as key to what I will call 'communist accelerationism'. We have seen that accelerationism is usually a strategy that tries to ride the infinitely self-expanding value of capital. Communist accelerationism, of the kind practiced by what Chris Arthur calls 'no-longer-existing socialism',[2] did something rather different. It tried to find a find a new and superior mode of production – one that could take the 'best' of capitalism, but reorganize it to go beyond the limits of a system driven by profit. In doing so it appealed, as we will see, to this 'cavalry-charge method', precisely to breakthrough to the future and, in doing so, to put human labor in charge.

My focus will be on the Russian Revolution, and the utopian dreams released as a result of that event. It's a commonplace that the revolution unleashed a new imagination of time and the place of the worker. Susan Buck-Morss remarks that: 'Machine culture, Soviet style, had its origins as the expression of a lack, so that

even its brutality could be seen to possess a utopian quality.'[3] In particular, as the later story from the later Cuban revolution illustrates, the factor of human labor was seen as key to accelerating beyond capital by bringing production under rational control.

Of course, this is a story of failure, violence, and brutality. The extreme suffering caused by these attempts to develop and control production is evident, especially for the peasantry. While in no way wishing to minimize or condone this, we should note that 'capital comes dripping from head to foot, from every pore, with blood and dirt'.[4] The fact that capital's processes of control and reproduction are often more 'indirect' obscures this historical violence from view, as does the fact that the victors write history. It was the desire to interrupt and develop a different form of production that drove the communist experiments.

Marx had explored how labor-power was the only commodity that generated surplus-value, the only commodity that could exceed its own limit due to its labor-power or potential. Capital, as 'the moving contradiction', depends on labor-power to generate surplus value but, on the other hand, it constantly tends to replace labor with machinery. The productive forces are the 'dead labor' that had become congealed and encrypted into machines and other devices. Lacking these advanced technologies, devastated by civil war, the new communist regime in Russia was forced to rely on labor. It was this use of living labor that seemed to be able to restore control and human will over the despotism of capital. Placing living labor first could be the first step into a new regime of production.

In the Highest Degree Tragic

'War communism' was the retrospective name given to the period 1918-1921 in Russia. In the face of civil war, international intervention, and the collapse of production, this was the 'degree zero' for the new Soviet society. Trotsky wrote: 'Russia – looted, weakened, exhausted, falling apart', and that matters were 'In

the highest degree tragic'.[5] Confronting the weakening of the proletariat through civil war, in whose name the revolution had been made, the new Communist state faced a life-or-death crisis. In response, infamously, Trotsky called for the militarization of labor in his *Terrorism and Communism* (1920). This call for 'an exceptional wave of labor enthusiasm',[6] is often regarded as a kind of hallucination induced by Bolshevik desperation. The usual argument is that the disastrous conditions of war communism were mistaken by the Bolsheviks for the capacity to give birth to communism immediately. In this case acceleration emerged from zero, from radical destruction.

This view is disputed by Lars T. Lih, who argues that Trotsky's calls for 'labor duty' and 'shock work' were not driven by fantasies of production, but rather a response to emergency conditions – what Trotsky described as 'the regime of a blockaded fortress with a disorganized economy and exhausted resources'.[7] That said, some Bolsheviks did see war communism, or would look back on it, as a site on which to radically rearrange capitalism starting from zero. A huge number of experiments and proposals emerged from this period, and continued into the partial restoration of capitalism in the period of the New Economic Policy (NEP) (1921-1928). War Communism, during which money ceased to function and production ground to a halt, seemed to demand new utopias to save the revolution.[8] The period of NEP, although restoring 'state capitalism', as Lenin put it, was also a time of relative intellectual freedom and experimentation. So, while not wanting to reinforce the usual image of the Bolshevik leadership as driven by a crazy 'euphoria', I do want to trace some of the debates and proposals that tried to restart devastated production in this period and aimed to fulfil the communist dream of offering a superior mode of production to capital.

One of the central points of this debate was the work on 'scientific management' of the American Frederick Winslow Taylor

(1856-1915), who introduced techniques of breaking down tasks into discrete units to improve efficiency and extract more labor. Writing in 1913 Lenin spoke of Taylorism as 'man's enslavement by the machine'.[9] In 1918, however, Lenin suggested that adopting Taylorism, under socialist organization, might offer a progressive measure. This dream of 'proletarian Taylorism' was aimed at minimising work by increasing its productivity so Soviet workers could have time to participate in the life of the new regime. The difficulty was that the management required to ensure this 'scientific work' would itself become dominant in the Soviet State.[10] The dream of 'proletarian Taylorism' remained a dream, but an influential dream.

The lag between the reality of devastation and the desire to embrace new capitalist technologies as the means to create a new communist society produced a contradiction. This contradiction would only become more acute as the European revolutions, especially in Germany and Hungary, were crushed, or failed to materialize. Susan Buck-Morss has argued that the Soviet avant-garde sacrificed the time of the avant-garde experiment, which is a 'lived temporality of interruption, estrangement, arrest',[11] for the vanguard time of progress to resolve this contradiction. While this difference between art and politics remained, especially in the dreams of new forms of production, the subor-dination of experimentation would eventually be completed under Stalinism. I want to suggest something a little different, and rather more disturbing. The time of certain elements of the avant-garde was a time of *acceleration*, which found itself in congruence with the vanguard desire for the future. While a gap between dream and reality remained, the avant-garde wanted not only to stop or interrupt time, but to force time into the future. So, this was active cooperation, rather than a chosen subordination. In the words of Vsevelod Meyerhold, theatre director and prophet of biomechanics, it was the time to create a 'new high-velocity man'.[12]

Iron Man

We can trace this desire to close the gap between present and future through the career of the proletarian poet Aleksei Gastev (1882-1939). His work takes the tension of harnessing communism to acceleration to an extreme. It seems to embrace the worst of regulated capitalist work and the alternative utopian re-imagination of work as strange site of freedom at the same time. Son of a school teacher, Gastev had a career as a lathe-operator, skilled metal worker, and tram repairman, as well as being a poet.[13] His 1913 'Factory Whistles' is characteristic:

> The crowd steps in a new march, their feet have caught the iron tempo.
> Hands are burning, they cannot stand idleness
> To the machines!
> We are their lever, we are their breathing, their impulse.[14]

We already have a sense of new speed – the 'iron tempo' – and of the integration of the animal body with the machine – 'we are their breathing'.

This vision of the transformative power of technology explored in his work 'Express – a Siberian Fantasy', written while in exile before the revolution. It presents a utopia of Siberia as a machine paradise viewed through the voyage of the express train 'Panorama'. This is a vision of Siberia laced with factories and roads, of the train 'drown[ing] man in metal', which violently reworks nature to human will. It is a world in which Russia will join-up with America to form a technological utopia and the Arctic ice-cap will be melted.[15] A reworking we would now contemplate with horror, thanks to global warming, carried then a dream of peace and plenty, of synthesis between later antagonists.

Gastev was shocked by the backwardness of Russian labor during the Civil War. Yet, he saw the destruction he witnessed as

the possibility of a new beginning. In his theoretical text *How to Work* (1923) he wrote:

Too much is destroyed, much destroyed to the point of madness, to the point that chronology is wiped out, but even more is begun, begun with open naiveté and faith. We have to accept all that, accept it without conditions, accept it as the emotional-political manifesto of the times and give ourselves up to the whirlpool of the new epoch, where the general platform must be bold rationalism.[16]

The end of chronology must be welcomed as the condition to plunge into the 'whirlpool' of a new epoch – a new time in which we can rationally grasp and control production. Already, on August 12 1920, Gastev had founded the Central Institute of Labor (1920-1938), and given up his role as poet and as Commissar of the Arts in Kharkhov.

Gastev's poetic utopian fantasies of 'machinism' and the engineering of souls would now be put into practice. The twin prophets for Gastev were Frederick Taylor, with his techniques of scientific management, and Henry Ford, for his creation of mass production lines. These capitalist heroes would become models for a new communist way of working. Gastev's vision was profoundly anti-humanist:

Soulless and devoid of personality, emotion, and lyricism – no longer expressing himself through screams of pain or joyful laughter, but rather through a manometer or taximeter. Mass engineering will make man a social automation.[17]

It was Gastev's vision of a mechanized society that would draw the ironic ire of Yvgeny Zamyatin, in his novel *We* (1921).[18] Zamyatin's hero D-503 would worship Taylor, like Gastev, as well as incarnating Gastev's dream of numeric designation for

people (Gastev had remarked that mechanization 'permits the qualification of separate proletarian units as A, B, C, or as 325, 075, or as 0'). Zamyatin would cast as dystopia what for Gastev was utopian promise.

Gastev was not alone. He cited a speech from 1923 by the Bolshevik Nikolai Bukharin to the Komsomol (the 'All-Union Leninist Young Communist League'), which declared: 'We must direct our efforts at creating in the shortest possible time the greatest number of specialized living machines that will be ready to enter into circulation.'[19] The 'living machine' is the dream of the rupture of existing production relations and acceleration beyond the limits of capital. The test of communism, in this view, is its ability to transcend and out-produce capitalism. Of course, this seemed to lead to the worst of both worlds: the adoption of the most dehumanizing capitalist techniques of management and the implementation of them in dictatorial and authoritarian form.

Gastev was not simply a prophet of the later Stalinist subordination of humans to production. His work, rather, is poised uncomfortably in the space of the transformation of both machines and labor, as Rosa Ferré suggests:

> Gastev's technical utopia is both an aesthetic concept with connotations of fantasy and sensuality in its praise of the machine, clean glass and steel, and a practical way of thinking aimed at improving workers' conditions: now to best avoid accidents, economise on labor and improve performance.[20]

His utopia is not predicated on the mobilization and brutalization of labor, such as that found in the use of slave labor under Stalinism. Instead, far from being a machine, animal, or robot, Gastev's worker is 'an active, sentient, and creative part of the productive process'.[21] In the spirit of Lenin's hopes for proletarian Taylorism the total subordination of the worker to work aims to free the worker to dream on the job and to escape the

rigours of work as quickly as possible for an active life. The incompatibility of Gastev's vision with Stalinism would soon become brutally apparent.

Tempos Decide Everything

Stalin engineered his rise to power after Lenin's death. In 1928 he launched the first five-year plan, which ended NEP and recaptured the utopian energies of War Communism in the cause of a violently rapid process of industrialization and a catastrophic war on the peasantry. The 'accelerationism' of this first five-year plan is evident in that it was completed in four years. The result was a far more radical and destructive reworking of society than had been undertaken between 1917 and 1928, but also 'the abandonment of all the varied, autonomous revolutionary utopian strivings in favour of the single utopia of Stalinism.'[22] The historical irony was that Stalin, the 'conservative', used utopian tropes against the utopians, insisting on discipline, obedience and conformity to achieve the necessary historical 'acceleration' (*uskorenie*), and 'slowing the tempo' (*gromozhenie*) would become a counterrevolutionary act. This 'Stalinist *jouissance*' offers the masochistic sacrificial 'pleasure' of acceleration through submission to labor.[23]

It was now Stalin who would control time, criticising those who tried to go too fast as being 'dizzy with success', while also insisting that any slowdown was unacceptable. A Stalinist slogan of time declared that 'In the epoch of reconstruction tempos decide everything'.[24] Andrei Platonov's surreal novel of Stalinist collectivization, *The Foundation Pit* (written in 1930, but only published in 1987), constantly recurs to the term 'tempo'. The novel concerns the digging of the foundation pit for a future house of the proletarians and the elimination of the kulaks, the 'rich' peasants, who are sent downriver on a raft.

It also includes perhaps the strangest attempt to characterize the new Stalinist tempo of shock work. The village blacksmith

has as his assistant the 'unknown last proletarian' and last instance of 'residual exploited labor' on the collective farm: a bear who hammers at the forge.[25] In fact the forge is a 'shock' workshop and the bear is not only the last proletarian but also the first shock worker (*udarniki*). After having been taken around the collective farm to denounce kulaks – in actuality, those who have mistreated him – the bear sees a banner 'For the Party, for Party loyalty, for the Shock Labor Forcing Open for the Proletariat the Doors into the Future!' Taking this injunction absolutely the bear begins to hammer out iron at a frantic rate, distressing the villagers as his labor threatens to ruin the iron.

The bear prefigures the destructive excess of 'shock work' as the storming of production, by trying to force the door for proletarian future by 'expending all this furious, speechless joy into the zeal of labor'.[26] Anna Epelboin sees the bear as figuring not only acceleration into the future but also as 'the agent of ultimate destruction' who 'threatens to return the world to primordial chaos'.[27] In Platonov's vision the Stalinist tempo reverses itself as the revolution turns into its opposite – destruction replaces production, and order is revealed as chaos.

The fate of Aleksei Gastev under Stalinism reflects the impossibility of adapting his utopian acceleration to this new form of Stalinist shock work. Gastev had written a collection entitled *Poeziia rabochego udara* [*Poetry of the Worker's Blow*] in 1918, which some have anachronistically translated as *Shockwork Poetry*. Gastev's attempt to rationally control work was, however, contrary to the 'storming' of shock work and the destructive chaos that resulted. Certainly Gastev did try to conform to the new regime, but the Stalinists recognized the incompatibility. In 1938 the Central Institute of Labor was closed and Gastev arrested on 8 September of that year, charged with 'counter-revolutionary terrorist activity'. He was found guilty and sentenced to death on 14 April 1939, and shot the next day. N. V. Ustryalov remarked, 'The revolution is merciless not only toward those who lag

behind it but also toward those who run ahead of it.'[28]

Gastev's end in Stalin's prison system also reveals something about this new Stalinist politics of productivity. Kate Brown has demonstrated that much of the 'work' of the Gulag, the prison and camp system that camp to dominate the USSR, can be understood as the disciplining and organization of labor.[29] In the absence of a regime of private property, which restricts people's settlement through the need to earn wages and afford housing, the Soviet regime used various forms of zoning and internal passport controls. The bulk of those incarcerated in the Gulag fell foul of these laws, so as well as providing slave labor the Gulag also served to restrict and control freedom of labor as well. Stalinist 'politics of productivity' rescinded the dreamworld of the integration of living labor into the machine, only to replace it with the brutal organization of slave and unfree labor through social regulation and spatialization.

Storming Heaven

Communist accelerationism, I have suggested, can be understood as the attempt to answer the capitalist dynamic in which living labor (i.e. people) is squeezed out by 'dead labor' (i.e. machines). Communist accelerationism tries to answer this dynamic in two ways. First, it tries to reverse the dependence of living labor on dead labor. For Marx dead labor in capitalist society 'subordinates labor instead of being subordinate to it, it is the iron man confronting the man of flesh and blood.'[30] Accelerationism, here and elsewhere, answers this problem by fusing the man of flesh and blood with the iron man – integrating man and machine, or person and machine, to fuse and infuse living labor into dead labor. This will mutate into the cyborg fantasy of the 'man-machine'. Rather than being reduced to the 'mere appendage' of the machine, the worker will control and direct the machine, reworking capitalist technology to communist ends.

33

Second, the machine will be used as a substitute for living labor, but not in the capitalist form which leads to unemployment or the misery of working for the machine. The bonding of living labor and dead labor means dead labor does not replace living labor, but rather they can coordinate and work together. The machine can be used to free-up people to engage in one of Marx's few positive views of a communist society:

> while in communist society, ... , society regulates the general production and thus makes it possible for me to do one thing today and another tomorrow, to hunt in the morning, fish in the afternoon, rear cattle in the evening, criticize after dinner, just as I have a mind, without ever becoming hunter, fisherman, herdsman or critic.[31]

This bucolic vision will, ironically, come about as a result of a thorough industrialization and resort to the machine to regulate and minimize labor.

This is the utopian dream of communist accelerationism, in which the seeming horror of the full mechanization of the human is, in fact, regarded as the freeing of labor. We might say, to adapt Lenin, that the formula is Taylor + Fourier = Communism. The techniques of Fredrik Taylor for work-place efficiency will lead to a Fourierist vision of engaged labor and free time. The result of such thinking, however, was 'in the highest degree tragic', as the fate of Gastev indicates. In fact the system could not achieve the dream which animated it. In an acerbic description Chris Arthur had noted that 'The Soviet system was not a labor-saving system but a labor-hoarding one.'[32] Labor was hoarded precisely to permit the moments of 'storming' to meet plan deadlines and this was a result of guaranteed employment. The 'problem' was that the labor discipline of capital, of which Taylorism was one influential ideological form, could not operate effectively. Yet, for the utopians of Soviet accelerationism this was the point. In this

guarantee new possibilities offered themselves. Of course Stalinism, through the Gulag archipelago, would generate new forms of labor discipline.

The repetitions of this scenario, which we mentioned briefly in regards to the Cuban revolution but which also speaks to the Maoist 'Great Leap Forward', would also repeat the tragedy. The new socialist economy would prove much more recalcitrant to serving labor than had originally seemed possible. It is this experience of failure, I would argue, that drives accelerationism to its acceptance and even celebration of the coordinates of capitalism. Rather than attempting to change the relationship of labor and capital, accelerationism celebrates the disappearance of labor *into* capital. In an uncanny fashion it fuses, as we shall see, elements of the communist dream of accelerationism with capitalism's own fantasies of self-engendering production.

3

Machine-Being

Thomas Brinkmann's 1998 minimal-techno track 'Maschine', recorded under the name Ester Brinkmann, includes a repeated voice sample that kicks in at 3.18. In German, the voice says: 'Ich will eine Maschine sein. Arme zu greifen Beine zu gehn kein Schmerz kein Gedanke.' 'I want to be a machine. Arms to grab [,] legs to walk [,] no pain [,] no thought.' The sample is the voice of Blixa Bargeld, lead vocalist of Einstürzende Neubauten, from their album *Die Hamletmaschine*, which is a score for Heiner Müller's play of that name. In Brinkmann's hands the sample repeats the techno trope of machinic acceleration and integration, from Kraftwerk through Detroit to Sheffield, in a semi-parodic fashion. What Nick Land had celebrated as 'manically dehumanized machine-music' is here slowed and repeated in a lulling techno rhythm.[1] The sample holds up for critical inspection the exit from feeling and consciousness ('no pain, no thought') promised by machinic integration that is, I will argue, the fantasmatic underpinning of accelerationism.

In this chapter I want to explore these fantasmatic and libidinal elements of the promised integration of the human with the machine, which is so prevalent within accelerationism. To do so I will treat two exemplary and widely-spaced moments: the first is Victor Tausk's psychoanalytic research on the 'influencing machine', published in 1919, shortly before his suicide by shooting and hanging in the same year. Freud remarked in a letter, with honesty verging on callousness, that 'I confess I do not really miss him; I had long taken him to be useless, indeed a threat to the future.'[2] Tausk's 'machine' would get an accelerationist retooling by Deleuze and Guattari in *Anti-Oedipus*, shifted from the status of fantasy to the Real of desiring-production. The

second moment is Thomas Pynchon's novel *Gravity's Rainbow* (1973), which explores the psychopathology of machinic integration in the context of the Second World War. Pynchon's novel would be taken-up as one of the texts subject to cyber-gothic remix by the Cybernetic Cultures Research Unit (CCRU) (which I will discuss in Chapter 4), and read as a manifesto of technological acceleration. My concern, in both cases, is to return to these moments as keys to the libidinal elements of the ideological fantasies of acceleration.

Mystical Machines

In his seminal essay *On the Origin of the Influencing Machine in Schizophrenia* (1919), Victor Tausk sketched out the pathological experience of identification with the machine that is suffered by certain schizophrenics.[3] He traced out how in this situation we feel controlled by a machine, which might make us see pictures, produce or remove thoughts and feelings, control our bodies, create strange sensations, or produce physical ailments:

> The schizophrenic influencing machine is a machine of mystical nature. The patients are able to give only vague hints of its construction. It consists of boxes, cranks, levers, wheels, buttons, wires, batteries, and the like. Patients endeavour to discover the construction of the apparatus by means of their technical knowledge, and it appears that with the progressive popularization of the sciences, all the forces known to technology are utilized to explain the functioning of the apparatus. All the discoveries of mankind, however, are regarded as inadequate to explain the marvellous power of this machine, by which the patients feel themselves persecuted.

If the apparatus is obscure, so is its operation: 'the patient rarely having a clear idea of its operation. Buttons are pushed, levers set in motion, cranks turned.' The black-boxing of technology –

in which the functions of a device are made opaque behind an interface, such as in the case of the computer – makes the experience of all machines something like these fantasmatic 'influencing machines'. This perhaps accounts for our experience of machines as persecutory, as when we bargain with devices in the hope they will work, or violently attack them. It is not only certain schizophrenics who fall under the influencing machine.

Tausk sees this pathological projection of the machine as developing from our alienation or estrangement from our own bodies. The pathology behind this process is due to the formation of the ego – the sense of self that distinguishes us from the world and which is lacking or eroded in the schizophrenic. Tausk argues that the origin of the influencing machine lies in a disorder of the libido at the early stage of narcissism, in which we identify with our own bodies and have no clear conception of the outside world. In particular, following Freud, Tausk sees the problem as being a result of a struggle with homosexual libido – libido directed towards our own bodies. The socially-unacceptable nature of such a desire drives us to project out this libido onto the world.

The child does not initially recognize their body as their own and as separate from the world. Instead they have to gradually recognize all its parts, what Tausk calls the 'disjecta membra' (scattered fragments), as parts of a whole and invest libido into the ego as the image of the whole body. Once this has taken place it becomes possible to project this image onto the world. The pathological projection of the influencing machine is a regression to the stage in which we are trying to find our own body through projection. We return to a sense of our body as mere fragments and therefore of a continuity between us and the world. To cope with the experience of anxiety that results as we fail to distin-guish ourselves from the world, libido is projected out and then returns to us as persecution: 'The estranged organ – in our case, the entire body – appears as an outer enemy, as a machine used

to afflict the patient.' The influencing machine is, therefore, 'a summation of some or all of the pathologically altered organs (the whole body) projected outward.'

When we start to feel our bodies becoming strange we explain this fact by projecting this feeling on to an 'influencing machine' which then becomes the 'cause' of our bodily alienation. In Tausk's words we move from 'the feeling of self-estrangement' to 'the delusion of reference'. The machine, however, remains inexplicable. For Tausk this ungraspable machine is a symbol and, more than that, a symbol of our own genitalia. In order to repress this fact we complicate the machine to disguise its symbolism, resulting in the complexity of the influencing machine.

It is this treatment of the machine as a projection that Deleuze and Guattari object to in *Anti-Oedipus*.[4] For them, machines can only ever be real, in the sense of the Real of productive desire. The Real is capitalized to indicate this is not the 'real' qua reality, but rather the excessive force of production that is only ever cooled-off to form the apparently 'real'. This is a metaphysics of the production of the Real as the Real of production. It is one form of the metaphysics of accelerationism, which can be more widely grasped as a metaphysics of forces – forces of production, of destruction, and human, mechanical and cybernetic forces, that must be welded or melded together into a plane of immanence. For Deleuze and Guattari this notion of the Real as immanent production is neutralized or led astray if, as Tausk does, it is conceived as a pathological symbol.

I want to stay longer with Tausk, however, to put pressure on the accelerationist desire to translate everything into Real production. Both terms – 'Real' and 'production' – are contestable as libidinal fantasy productions, which is my line of attack. The collapse of fantasy into the Real by accelerationists is, I'll argue, a sign of fantasy that tries to produce the Real as such. In doing so it evades the problem of the simulacral and fantas-

matic notion of production. This is a fantasy of the end of fantasy. It also evades the pathological and painful elements of this identification with the machine, the friction between the body and its integration, that this extreme experience attests to. With this in mind, let's return to Tausk.

Tausk's case study was based around 'Miss Natalija A.', a thirty-one year-old former philosophy student who believed she was being controlled by a machine operated by her ex-fiancée. The machine took the form of her body symbolized by a trunk having the shape of a lid of a coffin and lined inside with silk or velvet. At first the limbs of the machine were natural, and then merely drawn on the lid of the coffin. The head appeared to be absent. The inner parts of the machine consisted of electric batteries. For Tausk the machine is both a projection of the genitalia and the patient's body. As the projection gets stronger becomes more like a machine and less like a body to protect her from recognising herself in the machine.

The machine is operated by love objects, as a result of the transfer of libido. In fact in this situation some of our close love objects are also persecuted, which is because we do not distinguish them from ourselves because of our fluid ego-boundaries. So, those who operate the machine are love objects at more of a distance – doctors, lovers, suitors or, as with Natalija A., an ex-fiancée. The 'body' that is projected onto the machine becomes identified with the genitalia, which saturates the body into a libidinal zone. The increasingly unreal machine becomes an image of derealized libido, a receding figure of *jouissance*.

Deleuze and Guattari valorize this experience as the fragmented multiplicity of the schizo-machine that exceeds the normalized body and normalized ego enforced by psychoanalysts like Freud and Tausk. Against the wholeness and integration preached by psychoanalysis, which they see as the true paranoid fantasy, they try to free up these frozen projections into zones of exchange and interaction. The task of schizoanalysis

is not to force the patient to recognize a false projection and return it to the self, but to embrace the possibilities of fragmentation and dispersion that paranoia freezes.

While this offers a useful corrective to some of the normative projections of psychoanalysis, which admits fragmentation and multiplicity only to always insist on return to the ego and structure, it risks missing the anxiety and paranoia that marks the relation of humans to machines, and of humans to the machine that is our body. Instead of exploding paranoia through the accelerationist embrace of the schizo trip I want to follow more closely the problem that the 'influencing machine' reveals of our own machinic nature that coincides with the repetitions of labor and production.

Tausk emphasizes the libidinal dimension of this alienation, but we can also see the fear of our own becoming-machine – the machinic nature of our own libido and the increasing penetration of the machine into our bodies. Marx noted that the trend of capitalist production is to reduce us to a 'mere appendage' of the machine. In the case of the influencing machine this is literalized as we become libidinally manipulated by the projected machine. The choice to valorize the influencing machine by Deleuze and Guattari speaks to how they welcome this integration – the explosion of the body on the deterritorializing lines or flows of capital. We find the machinic body as saturated libidinal zone. The fantasy of the influencing machine, in contrast, interrupts this smooth circuit of integration, suggesting the fraught zone of transfer between body and machine that never achieves smooth integration.

Rocketman

In his mordant postwar reflections collected in *Minima Moralia* (1951) Theodor Adorno remarks on the effects of the new technologies of death on our conception of history:

Had Hegel's philosophy of history encompassed this epoch, then Hitler's robot-bombs would have taken their place, next to the death-scene of Alexander and similar images, among the empirically selected facts in which the symbolic state of the world-spirit is immediately expressed. Like Fascism itself, the robots are self-steering and yet utterly subjectless. Just like the former, they combine the utmost technical perfection with complete blindness. Just like the former, they sow the deadliest panic and are completely futile. – "I have seen the world-spirit," not on horseback but on wings and headless, and this at once refutes Hegel's philosophy of history.[5]

The 'subjectless' weapons – the V-1 flying bombs, and V-2 rockets – incarnate a refutation of history as potentially rational process. Today the world-spirit is not a person, for Hegel Napoleon, but a self-steering device. In contemporary terms, we might say the world-spirit is the drone.

In some enigmatic passages of *Speed and Politics* (1978) Paul Virilio turns to the metaphysics of metempsychosis – the transmigration of souls – to suggest the tension of the loading of the soul on to various metabolic vehicles. Virilio argues that the soul is 'plural, multiform, fluidiform, coagulated here and there in social, animal or territorial bodies.'[6] The philosophy or theology of the military class is Gnostic, in that it assumes the 'powerful' soul is deterritorialized, fluid and transferable, while the 'weak soul' is imprisoned within the body and the world. Virilio likens this powerful soul to the 'gyrovagues', wandering and itinerant monks often condemned by the church of the early Middle Ages for their parasitic mobility, selling of fake relics, and gluttony. In this military Gnosticism acceleration is not only the acceleration of the vehicle but the 'pure' acceleration of the soul moving smoothly from embodiment to embodiment, and so able to exceed any territorial capture.

For Virilio, of course, this deterritorialization is not to be

lauded. It incarnates the nihilistic politics of 'pure war' in which global space becomes a playground for these detached souls. Military Gnosticism, which incarnates a fantasy of pure mobility, finds a resonant literary figuration in Thomas Pynchon's 1973 novel *Gravity's Rainbow*. Set during the Second World War, the novel is partly a picaresque exploration of the wanderings of Tyrone Slothrop through the 'zone' – the remains of postwar Germany. Slothrop was subject to Pavlovian conditioning as infant, sensitising him sexually to the mysterious plastic Impolex G.[7] This plastic is used in the German V-2 rockets, and thanks to his conditioning results in pre-strike erections and sexual encounters for Slothrop. The conditioning makes Slothrop a machine controlled by the influence of his conditioning: 'erection hums ... like an instrument installed, wired by Them into his body as a colonial outpost'.[8]

Adrift in the zone Slothrop is 'thrown back on dreams, psychic flashes, omens, cryptographies, drug-epistemologies, all dancing on a ground of terror, contradiction, absurdity.' (582) This sketches in advance what might have been the adopted research programme of the accelerationists of the CCRU, who operated in the '90s and which we will encounter in Chapter 4. The absurd accelerative forces of the war fragment and explode Slothrop's identity, to the point where '[s]ome believe that fragments of Slothrop have grown into consistent personae of their own. If so there's no telling which of the Zone's present population are offshoots of his original scattering' (742). One of Slothrop's (in)consistent personae is the comic-book superhero 'Rocketman', which implies already the fantasy fusion of man and machine.

Slothrop is, however, subject to much more profound conspiratorial forces, from industrial cartels to the very way in which '[t]he War has been reconfiguring time and space into its own image.' (257) Pynchon, with tongue as usual somewhat in cheek, suggests that 'secretly, [the War] was being dictated instead by

the needs of technology ... by a conspiracy between human beings and techniques, by something that needed the energy-burst of war.' (521) 'War' and 'Technology' become forces demanding acceleration and the integration of the human into the suicidal 'war-machine'. They also code capitalist deterritorialization, as the 'Manual', on file in the War Department, states: 'The true war is a celebration of markets.' (105) In Pynchon's pessimistic and conspiratorial view the emergence of great systems of control operate precisely through energy and acceleration.

This reconfiguration takes its terminal form in the human passenger that is integrated into a remaining Nazi V-2 rocket, in an experiment staged by the rocket crew following the Nazi defeat. Of course, in agreement with Tausk, we could hardly have a more phallic fantasy of integration than the V-2. The V-2 is also a cryptic text or symbol, one 'to be picked to pieces, annotated, explicated, and masturbated till it's all squeezed limp of its last drop' (520). The V-2 is phallus as Spermatikos Logos, as endlessly interpretable symbol. Pynchon traces the theologies and heresies that surround the rocket, but never touch its core:

Gnostics who have been taken in a rush of wind and fire to chambers of the Rocket-throne ... Kabbalists who study the Rocket as Torah, letter by letter – rivets, burner cup and brass rose, its text is theirs to permute and combine into new revelations, always unfolding ... Manicheans who see two Rockets, good and evil, who speak together in the sacred idiolalia of the Primal Twins (some say their names are Enzian and Blicero) of a good Rocket to take us to the stars, an evil Rocket for the World's suicide, the two perpetually in struggle. (727)

The V-2 generates constant forms of heretical metaphysics, which try and fail to close the symbol around any 'Kute Korrespondences' (590).

In fact, the integration of the passenger with the V-2 is not so

much phallic as masochistic. The passenger is Gottfried, the lover of Captain Blicero, who Blicero has subjected to masochistic and incestuous rituals. This culminates in Gottfried's insertion into a special compartment in the V-2 while clothed in a shroud of Impolex-G. The fantasy here, although terminal, carries echoes of Jung's idea of incest as the possibility of re-birth and individuation, an idea which was also influential on Gilles Deleuze.[9] It also modifies Adorno's assertion that Hitler's robot weapons 'utterly subjectless'. The dream – masochistic in this case – is of the integration of the subject into the futile trajectory of the machine. Unusually, such a conclusion may be more pessimistic than Adorno's, as there is a subject integrated but they have no role in steering. This is in line with Adorno's pessimistic conclusions about the nullification of the subject in modernity, but this is a nullification that is welcomed and embraced. In Pynchon's text the accelerative fantasy of integration reaches a literally terminal point of self-cancellation.

And yet such a conclusion may be just another 'Kute Korrespondence', another theology of the V-2. It's certainly possible, as the CCRU did, to read *Gravity's Rainbow* as accelerationist. Rather than a fascist hardening or securing of identity through fusion, here we have dissolution and fragmentation through the fusion with the accelerative technologies of warfare. To use a much abused word, this is a postmodern accelerationism, that explodes or disperses the concentrated force of modernist or avant-garde acceleration. What Pynchon called 'soul-transvestism' in *V* (1963), or the 'fluidiform soul' as Virilio puts it, can be loaded or distributed across vehicles, to the point we welcome our own disintegration.[10]

We see a collapsing of fantasy, and also a collapsing of the fictional space, into the Real of production and acceleration. If someone like me should accuse this of a psychotic collapsing of our capacities for language and symbolization then the response can simply be you haven't really gone all the way... No matter

how impossible it might be to imagine or think a pure immanence the appeal to such an experience carries relentless attraction as utopian promise. To put fantasy into action, to realize ourselves as productive machines, to realize our scattering of personality as gateway, is the promise of accelerationism. And yet...

Virilio's insight into the boarding of metabolic vehicles, reinforced by Pynchon's provocation, suggests the metaphysical desire for integration and dispersion of human and machine at work in the dynamic of technology, military power, and capitalism. It is this dynamic of dispersion that is often lauded in contemporary accounts of protests and struggles, which are seen as instances of resonance between bodies, including technical bodies, that can resist power. The difficulty is that these metabolic vehicles, which is to say living bodies, risk being occluded by an assimilation of their struggles to the same dynamic by which capitalism insists that we are endlessly transferable and mobile labor. What is lost is a real sense of the friction or resistance of the body against integration into fluxes and flows, as the Real acceleration of struggles is seen as a line of flight from the limits of the State and capital.

Sex-Work-Machine

The experience of most work is of profound boredom and point-lessness – hardly one of acceleration. Work is the eternal 'hell of the same', as Baudrillard put it – repetitive and often ridiculous tasks to no good or even useful end.[11] Accompanying this experience is the erotic reverie, an experience of endless variation and exploration of erotic possibility both at and beyond work in a libidinal acceleration. Those familiar with the most boring forms of work – factory work, office work – will also be familiar with the endless exchanges and discourses about sex. Pornography is passed around, the sexual possibilities of colleagues discussed, and the mind is occupied with the libidinal.

The libidinal fantasies of machinic integration, 'pathological' as they are, suggest the utopian merging of libidinal acceleration with an acceleration of labor that is repetitive and machinic. For accelerationists this infusion or melding produces a multiplicity that explodes the limits of the ego in new vital possibilities. The real of production, as desire infuses the machine, ruptures the iterative routines. Work would (finally) be sexy. Although this is a state without feeling or thought, which could also suggest that sex might be worklike...

If, as psychoanalysis suggests, our experience of sexuality is fundamentally repetitive and boring then this fusion does not have to go far. The seeming endlessness of erotic possibilities becomes frozen in the tableaux of our own singular drives. It is the work of the Marquis de Sade that demonstrates this mode of possibility as repetition and, even, as labor. The relentless iterations of the *120 Days of Sodom* (1785) produce the deadening sense of timetabled labor, increasing in intensity and activity. Adorno remarks that Sade's 'orgies are arranged like mechanical ballets.'[12] I'm suggesting that we don't simply confront the integration of fluid and mobile life into deadening and alienated labor, but also the desire to integrate the repetitive and deadening circuit of the sexual drive into the deadening circuit of labor. While accelerationism might promise an integration of desire and labor in a machinic 'synthesis' to accelerate the boredom of work it disguises the boredom of desire. Accelerationism wants to enchant sex as something accelerative and machinic, away from the iterative reverie of fantasy.

The fantasy of integration is the fantasy of abolishing fantasy. What accelerationism promises is the integration of the person into machine, of sex into work, and the generation of the Real of production. In this way fantasy as the access to the Real is collapsed into an immersive and immediate experience of the Real without mediation. Although couched in terms of the libidinal, what is extinguished is the libidinal, as accelerationism

reproduces the deadening experience of labor as the site of masochistic enjoyment. At the same time contempt is often expressed to *actual* workers for their failure to fully 'enjoy' this situation. The result is an evasion of the deadlock of desire through the claim to immediately access desire and fantasmatically dissolve the deadlock. This is the libidinal fantasy of accelerationism.

4

Cyberpunk Phuturism

There seems to be little place for the modernist linear-dynamics of progression and acceleration that I have traced in the dispersed and slackened forms of postmodernity. Whether futurists, capitalists, or communists, the avant-garde 'passion for the real',[1] that tried to accelerate us to new human types, now seems quaint, kitsch, and politically dubious. And yet the dream and reality of speed machines is not merely the province of dubious nostalgia to be found in the remnants of petrolhead macho excess or in the fetishization of contemporary military technologies.

Acceleration, today, passes from the car, the quintessential technology of mass speed and modernity, to the computer. If the car, as Enda Duffy argues,[2] was the lived experience of modernist time for many – a new mass aesthetic, when modernism tended to the hermetic – then the computer plays that role today. It is the computer, especially for those who work with them, that embodies the 'speed-up' of labor, as each new model becomes faster and faster (or that is the promise). The Internet provides the 'one-click' solution, computers speed-up and slim down, seemingly providing one of the last utopian remnants worthy of any commodity fetishism; the very frustration of a computer slowing down or freezing-up indexes our own internalized demand for speed. The computer also now vectors the alliance of speed and war, as the acceleration of computer processing permits the rapidity of 'fire-and-forget' warfare, the drone attack, the militarization of civilian space, and, in US-military jargon, the 'compression of the kill chain'.

So, the integration of the accelerating man-machine does not simply disappear, but mutates. Fredric Jameson comments:

there are no great utopian texts after the widespread intro-
duction of computers (the last being Ernest Callenbach's
Ecotopia of 1975, where computers are not yet in service).
Instead, we have the freemarket deliria of cyberpunk, which
assumes that capitalism is itself a kind of utopia of difference
and variety.[3]

Cyberpunk is the utopia not only of difference and variation, but
also of deliria and acceleration. It is that 'utopia' I want to
explore, which is rather more durable and robust than Jameson's
dismissal might suggest.

This new aesthetic can be thought of as the attempt to
recapture the energy of the classical avant-garde in the slackened
time of postmodernity. It is not simply the repetition of the avant-
garde, but a mutated and modulated futurism, which, in typical
postmodern fashion, straddles between genres, forms, and
cultural domains. This is what I will call 'cyberpunk phuturism'.
Certainly 'cyberpunk phuturism' has an anachronistic and kitsch
ring. The term 'cyberpunk' did not really recover from Billy Idol's
album of that title, released in 1993. 'Phuturism' is my adaptation
via the Chicago Acid House practitioners Phuture, whose 'Acid
Tracks' (1989) has a claim to be the first Acid House record. That
said, perhaps the kitsch element, as we'll see, reflects something
of this aesthetic.

I will focus on three moments: cyberpunk fiction, Detroit
techno, and their synthesis in Cybertheory. In line with my
general argument I am not interested in simply expressing disen-
chantment with this avant-garde and celebrating chastened
conformity to the 'democratic' protocols of the present. Instead, I
want to probe these re-tooled forms of accelerationism as a
response to the mutations and continuities of contemporary
capitalism. Accelerationism is not merely an historical curiosity,
but an aesthetic and political attitude that continues to exert a
gravitational pull on the present.

The Thrill and Threat of Materialization

The Ur-text of cyberpunk phuturism is William Gibson's *Neuromancer* (1984), which is perhaps its most effective manifesto and predicts all its later mutant forms. *The* novel of cyberpunk science-fiction, and to my mind the only successful work of this form (along with its sequels), it tracks the new shifting forms of cybernetic embodiment. The very technology of 'jacking-in' to cyberspace is rooted, within the novel, in the frame of military technologies: '"The matrix has its roots in primitive arcade games," said the voice-over, "in early graphics programs and military experimentation with cranial jacks."'[4] Also, the well-known description of 'Night City' as 'a deranged experiment in social Darwinism, designed by a bored researcher who kept one thumb permanently on the fast-forward button',[5] prefigures the neoliberal future, and the compulsive attachment to the speed that promises to break the shackles of social confinement. The simile suggests, in the figure of the 'bored researcher', that this deregulatory fantasy has more than an element of (anti-) planning and direction, contrary to fantasies of the acephalic market. While speed is the promise of the opening to a new deterritorialized fluidity of social and virtual space – beyond the Fordist social-compact and the 'static' segmentations of social democracy – this is no blind process. The historical significance of Gibson's novel (leaving aside aesthetic judgements) lies in the fact that it is poised between anxiety and endorsement, critical distance and immersive *jouissance*, in its vision of cyberspace, augmentation and the accelerative disembedding of social relations.

Joshua Clover points out that *Neuromancer* incarnates the 'thrill and threat of dematerialization' that lies at the heart of neoliberalism;[6] the thrill of new fluid forms of accumulation and super-wealth (for a very few), and the threat of obsolescence and abandonment (for many). In Gibson's novel the thrill lies in the discarding of the ego, 'de-sleeving' consciousness, to borrow a

term from Richard Morgan's sci-fi novel *Altered Carbon* (2002), from its material support. The threat lies in being condemned to the 'meat' (the body), and excluded from the delights of cyberspace. This is the fate of the hacker Case at the beginning of the novel, who has had his capacity to jack-in surgically removed as punishment for an earlier entrepreneurial failure. Yet we could rewrite Clover to say that say that the novel's cyberpunk phuturism also captures the 'thrill and threat of *materialization*'. The thrill here is augmentation and integration, from Tally Isham ('the girl with the Zeiss-Nikon eyes') to Molly Numbers (with her implanted retractable razor blade implants). The threat is from bad tech, bad surgery, and falling behind the accelerative race to the future. Acceleration into the utopian horizon of capitalism – as a social form of pure drive and accumulation, freed from its dependence on the meat of labor – is always haunted by our obsolescence. Gibson's novel tracks a capitalist utopia in dystopian formulations, figuring the self literally as the 'entrepreneurial machine' that Foucault had already anatomized as the subjectivity of neo-liberalism.[7]

Techno-Phuturism

Cutting to another scene, it is, I would argue, Detroit techno that forms one of the most fascinating and most aesthetically successful instances of cyberpunk phuturism. Deliberately couched as a post-industrial Afro-futurism, it aimed to 'erase the traces' (in Brecht's phrase) of the Fordist sound of Motown and to mimic the new robot production-lines that had displaced the remains of 'variable capital' (i.e. humans) for 'constant capital' (i.e. machines) at Ford. This so-called 'automation' was called 'niggermation' by radical black workers in the 1970s – the systematic forcing-up of production under unsafe conditions through super-exploitation.[8] They disputed the story of new hi-tech production, noting that what was happening was often just old-fashioned speed-up on the line. Once again, we might be

cautious about the images of acceleration we encounter.

Detroit techno traced the mutating social space of Detroit – from the 'white flight' following the 1967 insurrection, the de-industrialization that followed, and its own position in the suburban site of Belleville High, where the pioneers Derrick May, Juan Atkins, and Kevin Saunderson met. Mixing European influences (Kraftwerk, New Order, Depeche Mode, etc.) with the Detroit funk of Parliament / Funkadelic, the result was a singular form that defied the studied reflexes of postmodern collage for an *integrated* acceleration.

The axes of Detroit techno were an increase in speed (in bpm) from previous forms of disco and House and a stripping-out of the humanist residues that often dominated those forms – not least the voice. The singularity of its aesthetic invention lay in this welcoming of the 'mechanization', or better 'computeri-zation', of the aesthetic (which had obviously been prefigured by Kraftwerk's *Man-Machine* (1978) and *Computer World* (1981)). The apotheosis of the form, at least as I regard it, is the work 'It is what it is' (1988), by Rhythim is Rhythim (aka Derrick May). This was, as one semi-ironic description of the time put it, 'dance music with bleeps'. Retaining funk, the insistence of Detroit techno had the utopian, if not kitsch, elements of sci-fi futurism coupled to the dystopian fragmentation of the city-space ('Night Drive Thru Babylon', as the track by Model 500 had it). Again, the equivocations lay in a sense of abandonment: an escape to the future, escape from labor, or the loss of labor and the collapse of the future into permanent unemployment?

The Detroit electro/techno-duo Drexciya, who emerged in the '90s, made explicit a longer history of disposable laboring bodies. Their name, as revealed on their 1997 album *The Quest*, referred to an underwater country populated by the unborn children of pregnant African women thrown from slave ships who had adapted to their underwater environment.[9] This Afrofuturist sci-fi vision placed cutting-edge contemporary

techno in contact with the abandoned bodies who 'escaped' the fate of slavery and their descendants who labored in Detroit's factories, before being abandoned by capitalism to destitution, drugs, and prison. Here the future is haunted by the traces of impossible labor, which ruptures with the possibility of an accelerationist continuum.[10] Detroit techno could be re-read, along these lines, as a critique of the 'smoothness' of acceleration, by a repetition that disrupts the future rather than the endorsement of accelerationism.

Cybergothic Remix

The splicing of these two moments, and the real instance of full-blown cyberpunk phuturism in explicit accelerationist form, can be found in the 1990s work of Nick Land and his allies in the Cybernetic Culture Research Unit (CCRU). This 'nomad' (anti-) academic grouping, formed at Warwick University in 1995, couched its 'disjunctive synthesis' of the drives of sci-fi and techno through the work of Gilles Deleuze and Félix Guattari, especially their *Anti-Oedipus* (1972). The aim was to format an avant-garde practice that would explode the limits of 1990s inertia.

The 'rush' of this cyberpunk phuturism operated through a new radicalization of acceleration. Vectored through cyberpunk fiction and the post-rave speed-up of Jungle and drum-and-bass, Nick Land and the CCRU's discourse aimed at maximum intensification into immanence until 'impending human extinction becomes accessible as a dance floor'.[11] The mass drug experimentation of rave culture was also spliced into this mutagenic remix. It aimed at immersion in immanence that had been, according to Nick Land, already realized in the then-future of 2012 (!). In case of present scepticism we should note Land's prediction is hyper-stitional – a kind of performative fiction, which creates the future it predicts – and that his theorization (according to Land) disrupts linear, chronological time. In the present moment we

only have traces of that future – drugs, sci-fi, Jungle, theory, biotech – that prefigures the meltdown to come: 'as if a tendril of tomorrow were burrowing back.'[12]

The project of this race to the realized future is best captured in Nick Land's restatement and remixing of Deleuze and Guattari's original accelerationist formulation. Land gives this accelerationism a deliberately provocative and late-punk anti-socialist and anti-social democratic form:

> Machinic revolution must therefore go in the opposite direction to socialistic regulation; pressing towards ever more uninhibited marketization of the processes that are tearing down the social field, 'still further' with 'the movement of the market, of decoding and deterritorialization' and 'one can never go far enough in the direction of deterritorialization: you haven't seen anything yet'.[13]

Machinic revolution, in Land's metaphysics, reaches out to the horizon of absolute deterritorialization – the realized capitalism that has decapitated itself into full-blown immanent marketization.

This posing of the market *against* capitalism was derived from the historian Fernand Braudel. Obviously markets have pre-existed capitalism, and Braudel suggested that capitalism formed itself as a monopolistic anti-market, tying down exchange. For Braudel, however, the virtue of markets was that they were face-to-face, localized and controllable. The problem of capitalism as anti-market, especially financialized capitalism, was that it was speculative, opaque and exceptional.[14] Land mutates this argument to identify markets with monstrously powerful cybernetic forces, which are 'speculative, opaque and exceptional'. It is these forces of exchange that can resist the *stagnations* of capitalism. A purified capitalism, shedding the dictates of the State, would traverse to a pure market accelerated out of capitalism altogether.

This theory fed-off the localized economic 'boom' of the '90s in which, at least in the UK and US, regimes claiming some tenuous and residual connection to social democracy instantiated a further deepening of the neoliberal project. It would be this coupling of attenuated social-democracy and neo-liberalism that bred a series of ideological tropes that dominate the perception of that moment, the '00s, and the present time of crisis. In this discourse it was the 'left' (or pseudo-left), and the 'left' in State power, that authorized, ratified and exacerbated the excesses of financialization and consumer credit. It was the spending of the State and the public sector, not the excesses of capitalism, which came to be treated as the 'dead weight' that is now holding us back from another leap into the future. Politicians of the present can play the austerity card in the elimination of this State and public debt, while accelerationist positions can argue that the only problem was the State itself, which did not unleash these processes far enough. It was the 'humanist' residues of State spending that failed to measure up to the anti-humanism of capitalism.

The position of the CCRU, despite its radicalized anti-humanism and inhuman immersive promise of capitalism exploding its own limits, resonates with these contemporary ideological claims that capitalism wasn't really allowed to follow through. In this narrative, the acceleration of capitalism was held back by State spending and State regulation (focused, in the UK, often on 'health-and-safety', as in the trope of 'health-and-safety gone mad'). It was a 'left' failure of nerve to go all the way to capitalism (and not all the way to the left...), that leaves us in the situation we find ourselves in.

This story of constrained capitalism was coupled, in the work of Nick Land, to a switch to China as the only State formation *really willing* to go all the way, or that had *already* gone all the way, as 'neo-China arrives from the future'.[15] What China could offer, in its post-Maoist embrace of capitalism, was the final synthesis

between Stalinist acceleration ('shock work', rapid and violent industrialization), the Maoist 'great leap forward', and capitalist acceleration (although, of course, the ultra-left had long argued Stalinism was really a form of State-capitalism and 'primitive accumulation'). The State-directed excesses of China, in its uncompromising developmental drive, become a *utopian* element. Hence Land's decamping from academia to work as a journalist in China was the personal embrace of this trajectory. His more recent toying with the neo-reactionary theories of Mencius Moldbug (aka computer scientist and entrepreneur Curtis Yarvin) renders critique of this latest work superfluous.[16]

The anti-Statism of cyberpunk phuturism is more opposition to *particular* kinds of State, and makes the demand for a State that is willing to acephalically decapitate itself – in 'special zones' – to engage in self-termination (allowing that this is certainly not what the Chinese State is doing). It leaves exposed the toxic core of capitalism, hence its anti-ideological drift, but this exposure aims to reconnect and exacerbate this core to meltdown.

The political vagaries of these aesthetic forms of acceleration do not fall on the tired tropes of fascism and 'totalitarianism', but rather on this difficult and tense imbrication with the dynamics of capitalism. Implicit in cyberpunk phuturism is not only the logic of increased computing speed and power, but also the claim that capitalism is maintaining its dynamic of acceleration first given its most memorable form by Marx and Engels in 'The Communist Manifesto' (1848). While we are all familiar with the line that 'all that is solid melts into air', the more resonant line for cyberpunk phuturism, especially as articulated by Nick Land, is: '[the bourgeoisie] has drowned the most heavenly ecstasies of religious fervour, of chivalrous enthusiasm, of philistine sentimentalism, in the icy water of egotistical calculation.'[17] Land's work dissolves the ego in the flows of this 'icy water', although the cult of personality that developed around him indicates the paradox of calls to dissolve the ego: some kind

of ego has to be there to experience this dissolution into immanent flux and to theorize or report on its own extinction.

This drowning of the ego is closely linked to the question of labor. It is as laboring subjects we are subjected to the ego and it is in the cyberneticization of labor that we are redeemed from the ego. In his text 'Meltdown' (1996) Nick Land proclaims: 'Industrial machines are deployed to dismantle the actuality of the proletariat, displacing it in the direction of cyborg hybridization, and realizing the plasticity of labor power.'[18] It is this integrated plasticity that reshapes the proletariat from subject of history into disappearing vector of acceleration. The displacement of labor will not be achieved by communism, or communist accelerationism, but through capitalism's dynamic. Another of Land's formulations, from 'No Future' (1995), paints a more horrifying fate: 'The full labor-market cycle blurs into meat-grinder.'[19] Now the fate of labor is not simply to disappear into an accelerated future, but to be processed as if in a meat plant. Land's statements code the paradox of extinction in-and-through machinic acceleration. The cybernetic machine is at once liberation from the meat and destruction of the meat, resolved in the *jouissance* of immersion into immanence.

Land's final theoretical texts, from the late '90s and then mid-'00s, explore non-standard numeric and alphabetic anti-systems. These deeply strange experimental texts, which engage with the QWERTY keyboard and with esoteric Kabbalist number systems, explode into a hyper-rational deliberate non-sense. They continue Land's project to break with the despotism of Western reason through a parodic hyper-reason, through an acceleration into the iterative. In a strange convergence with the qualitative mathematics of late Futurism, Land became interested in the numerical as a medium of counter-practice, a new technics. I think this could also be considered a response to the digital field of the computer, trying again to inscribe disruptive moments of fatal acceleration within and beyond the accumulative field –

releasing the 'energy' of numbers.

The bursting of the dot.com bubble on Friday 10 March 2000, which indicated the emptiness of the cybernetic regeneration or reinforcement of the productive forces, didn't simply wreck Land's programme. Instead it became more frantic, more intensive, and more weird, as it tried to extract any remaining vestige of dynamism from the series of financial shocks that wash round the global capitalist economy.

Stasis Today

The contemporary moment is nicely summarized in Fredric Jameson's remark from 1998: 'Stasis today, all over the world … certainly seems to have outstripped any place for human agency, and to have rendered the latter obsolete.'[20] The failure of agency leads to the accelerationist dream of the reinsertion of agency by the merging of humans and computers in a new technological synthesis. Gopal Balakrishnan, in his recent survey of the deceleration of global capitalism, notes that Fredric Jameson's account of postmodernism and the excess of global capitalism was initially predicated on 'unleashed nuclear and cybernetic productive forces', before 'the locus of the problem silently shifted to mapping an opaque, pseudo-dynamic world of financial markets.'[21] At the centre of both is the speed-machine of the computer. We might say that the shift in Jameson's work is the one not fully taken by cyberpunk phuturism, which remains at the first moment. In fact, cyberpunk phuturism often implicitly posed the first dynamic of 'cybernetic productive forces' against the emergent sense of the 'opaque, pseudo-dynamic world of financial markets'. This is explicitly the case in contemporary accelerationism's ambiguous discussion of 'accel-erative' elements of financial capitalism, such as High-Frequency Trading (HFT).[22]

For all their postmodern panache, cyber-accelerationism was far more concerned with the exploding of opacity, rather than the

revelling in the usual clichés of the play of signs or simulacra. In that sense, they do not simply play 'real production' against 'fictional finance', but rather try to *produce* the Real as the Real of *production* and *circulation* (combining Deleuze and Guattari with Lyotard). That is why I have argued that cyberpunk phuturism is a postmodern 'passion for the real', passing through the forms of simulation and semblants to accelerate out and beyond the antinomy of circuit and flesh.

Of course, the difficulty is that it involved a certain attachment to an accelerative dynamic of 'productive forces' that proved illusory, although this was something of a material 'transcendental illusion' generated by capitalist forms of value. Capitalism's drive to accumulation, its squeezing of labor, and its penetration of existence through abstraction, shape the conditions of our experience giving rise to a felt experience of dynamism. Accelerationism enhances and celebrates this, but the future it could not grasp was the future of crash and crisis – the terminus of acceleration in the grinding to a halt of the speed machine of capitalism.

This slowing-down did not signal the end of cyberpunk phuturism. Accelerationism is, as we will see, remarkably resilient. In response to the drawn-out moment of crisis, which resists being cast as the punctual interruption to capitalist service soon to be resumed, the attraction of the return to speed is an unsurprising development. This desire can gain purchase precisely through the resistance to the slowing-down of the moment of crisis, and the self-serving and nostalgic language of austerity being deployed as its remedy ('Keep Calm and Carry On'). Also, the process of creative destruction that is ensuing, to supposedly 'free up' capitalism from its own contradictions, can become recoded as a new piercing of existing barriers, including that of subjectivity itself. The accelerationist desire can revel in the apocalyptic destruction caused by the crisis, or used to resolve the crisis, and take this as the sign of a new take-off. If, as

Marx said, '[t]he *real barrier* of capitalist production is *capital itself*, then cyberpunk phuturism can pose itself as the transgressive desire to surpass that barrier 'beyond capital'.[23]

The difficulty is that this 'barrier' is, in fact, what serves the 'dynamic' of capitalism as contradictory social formation. The perpetual desire to purify and pierce the barrier of 'capital itself' is encoded within the genetic structure of the capitalist social relation. This leaves cyberpunk phuturism in the uncomfortable position of joining with those attempts by the managers of capital to induce movement and acceleration by removing the dead weight of variable capital. This confluence can be seen as a result of the attempt by cyberpunk phuturism to resolve 'the moving contradiction' of capital. It does so by integrating labor or variable capital *into* constant capital. The potential obsolescence of labor is resolved by a violent sublation into the machine, or more precisely the computer or cybernetic device. Then the constant acceleration of the computer, via increases in processing power, memory, or software upgrades, promises the upgrading of the integrated meat that can finally keep pace with capitalism: Labor 2.0, or 2.1, and so on. We have the 'immortality' of labor not as 'mere appendage' of the machine, but as integrated within it.

Virilio remarks that: 'The Japanese Kamikaze will realize in space the military elite's synergistic dream by voluntarily disintegrating with this vehicle weapon in a pyrotechnical apotheosis; for the ultimate metaphor of the speed-body is its final disappearance in the flames of explosion.'[24] This is the apocalyptic realization of speed-body indexed to military acceleration (as we saw in Chapters 1 and 3); another realization takes place in the dream of cyberpunk phuturism indexed to capitalist acceleration – the disappearance in *integration*. The perpetual-motion machine of capital generates the perpetual temptation to cybernetic accelerationism. One more effort, if we are to really speed-up capitalism, one more effort to dispose or displace the drag of

labor and the meat. The difficulty, at its heart, is that cyberpunk phuturism gives over to capital a monopoly on our imagination of the future as the continuing intensification of accumulation and the reinforcement of the capitalist continuum.

5

Apocalyptic Acceleration

In a time of crisis, apocalyptic desires and fantasies become pressing and real. Norman Cohn's *In Pursuit of the Millennium* (1957) offered a secret history of the periodic emergence of a 'revolutionary eschatology' in the Middle Ages in response to a collapsing social order, immiseration, disease, and war.[1] Responding to crisis these dreamers dared to imagine an apocalypse that would turn the world upside down, and create a new heaven on earth in which Princes would bow to peasants. The apocalypse that became real was the apocalypse of repression. During the Peasants' War in Germany (1524-26) over one hundred thousand peasants were killed and Thomas Müntzer, one of the leaders who, under torture, proclaimed *'Omnia sunt communia'* ('All things are to be held in common'), executed. Cohn, an anti-communist liberal, regarded these millenarians as dangerous forerunners of the 'totalitarian' movements of the twentieth century and, in the 1970 edition, extended this to condemn '60s counter culture by linking these medieval proto-anarchists to Charles Manson's death cult. Guy Debord and the Situationists would deliberately re-purpose Cohn, reclaiming these rebels not as symptoms of irrationalism but as forerunners of modern revolution.[2] Apocalyptic desires are ambiguous: at once consolatory fantasies, deferred hopes, and, potentially, spurs to radical re-orderings.

We are living in a time of crisis and potential apocalypse, with the overlapping of the financial crisis, ecological crisis, and the crisis of movements of resistance. This rupture of the capitalist continuum results in an apocalyptic imagination that produces dreams or nightmares of a world 'cleansed' of humanity, from 2012 to the History Channel's *Life After People*.

These fundamentally reactionary fantasies can only imagine redemption of our fallen world on the condition that humanity ceases to exist, or is reduced to the 'right' number of the 'saved'. There is, however, another apocalyptic tone that also runs through radical and revolutionary thought in the present moment: apocalyptic accelerationism.

If the current conjuncture of overlapping crises – financial, ecological, and political – figures the bad side of history at its worst, then apocalyptic accelerationism tries to radicalize the worst. To choose some examples, we have Franco 'Bifo' Berardi's contention that the current crisis is actually the sign of the demise of capitalism under the pressure 'of the potency of productive forces (cognitive labor in the global network)';[3] the claim by Angela Mitropolous and Melinda Cooper that the crisis is generated by 'usury from below ... that extended beyond the limits which were tolerable to capital';[4] and Antonio Negri's argument that 'no New Deal is possible', and so we must go on to more radical demands.[5]

All these thinkers are trying to call for a new inventiveness in the face of crisis and resisting, rightly I think, the usual calls for sacrifice and austerity – calls which usually fall on the victims of the crisis rather than those who caused it. That said, they also imply that by a kind of radical or quasi-Marxist 'cunning of reason' the very worst will produce the 'good' and remain within the ambit of Marx at his most accelerationist. The desire is, again, to immerse in the destructive element to extract a power that can shatter capitalism. Apocalyptic accelerationism tries to speed the rupture of the capitalist continuum by fusing with it, trying to integrate with forces that exceed control. It is this immanent apocalypse that I will dispute.

Immanent Tendencies

We can track the problem of immanence and acceleration through exploring the multiple uses of Marx's concept of the

tendency. This concept makes a key appearance in volume three of *Capital*, with what Gopal Balakrishnan calls Marx's 'notoriously unclear' reflections on 'the tendency of the rate of profit to fall'.[6] Marx's assertion is that this tendency will result, subject to counter-tendencies, in the long-term crisis of capitalism. It has led to a lengthy and vituperative debate, which continues today.[7] I will not address this debate, but instead focus on how Marx's remarks on the tendency became re-worked into a method of analysis. It is the tendency that is seen as the key to unlock the possibilities of crisis and rupture.

Crucial here is Lukács's *History and Class Consciousness* (1923) and his argument, in the central essay on 'Reification and the Consciousness of the Proletariat', that the tendency is the key tool in allowing us to grasp the historical process by dissolving the reified appearance of capital. Lukács notes, pertinently to acceleration, that: 'This image of a frozen reality that nevertheless is caught up in an unremitting, ghostly movement at once becomes meaningful when this reality is dissolved into the process of which man is the driving force.'[8] The image of 'reality', which is at once frozen and in movement, has to be dissolved to reveal the actions of people that generate the world of capitalism.

The tendency has a particularly tricky form – a dialectical form in fact – in which 'the objective forms of the objects are themselves transformed into a process, a flux.' (181) This 'flux' is no Bergsonian 'duration' (*durée réelle*), which is merely 'vacuous' according to Lukács, but a tracing of the 'unbroken production and reproduction of … [social] relations'. (181) Of course, the tension is that such a dissolution of the (reified) 'facts' can easily be regarded as mere speculation detached from reality, which is often the way in which the dialectic has been taken by bourgeois thought, and even by certain forms of Marxism. Lukács recognises that this is a 'theory of reality which allots a higher place to the prevailing trends of the total development than to the facts of the empirical world'. (183). It is the very *immediacy* of 'facts'

which is the sign of their reification, and instead the tendency returns reality to its mediation, to the complex totality that can only be truly registered, and so given 'empirical' confirmation, from the standpoint of the proletariat. The method of the tendency is therefore constitutively ambiguous because, necessarily departing from the 'facts', it can only be successful if confirmed in and by revolutionary practice.

Of course my brief overview of the contemporary apocalyptic tone would suggest that Lukács is not at all the key reference point. If the current financial crisis has its roots in the breakdown of the Fordist compact in the 1970s and the switch to financialization to deal with dropping corporate profits, then it may not be surprising to find that the contemporary apocalyptic tone is also rooted in that moment. These examples of contemporary post-autonomist thought all take off from the fusion of the work of Negri with that of Deleuze and Guattari. In particular they draw on Negri and Deleuze and Guattari's re-imagining of the concept of the tendency in the early 1970s. I am not suggesting a simple isomorphism between capitalist base and theoretical superstructure; after all this retooling of the tendency was precisely an attempt to articulate a theoretical means to grasp the precise effects of the economic 'base'. I am, however, suggesting that we do not simply regard theory as a hermetically-sealed realm that has no relation to economic, political, and social forms. In fact, as will become clear, this is a moment of theoretical reaction and response to the crisis of Fordism.

In the case of Negri, his canonical statement of the method of the tendency is given in his 1971 work 'Crisis of the Planner-State'. At this point Negri remains within remarkably classical and dialectical terms, arguing that: '[t]he tendency gives us a determinate forecast, specified by the material dialectic that develops the factors comprising it.'[9] In a similar fashion to Lukács Negri correlated the tendency with the viewpoint of the workers and also stressed that:

the procedure of the tendency is far from being rigid or deterministic. Instead, it represents an adventure of reason as it comes to encounter the complexities of reality, an adventure of reason that is *prepared to accept risks*: in fact, the truth of the tendency lies in its verification.[10]

As in Lukács the tendency is here deliberately pitched between the necessity of departing from the 'facts'; it is 'an adventure of reason', but also returning to a newly re-ordered world through the mechanism of revolutionary verification.

Negri's practising of this method in the 1970s was predicated on accepting and radicalising the crisis of the Fordist social compact to license a thinking of the imminent and immanent apocalypse of capitalist relations. If capitalism started to rupture the structure of the factory and guaranteed employment then one should not regret this and go backwards to some lost world of social democracy, but push the tendency further into exodus, sabotage, and destruction of the 'fetters' of the remnants of Fordism. This is a form of the accelerationism of struggles.

The implication of his work, reflecting on the crisis of Fordism and its 'planner-state', was that communism had already arrived and would need to simply be realized. Negri was obviously 'prepared to accept risks', and the uncharitable could say that his own reading of the tendency fell victim to the *failure* of verification, with the defeat of the movement of autonomy and Negri's imprisonment. This failure did not, however, lead to a further nuancing of the method of the trajectory in his work. In *Empire* (2000), co-written with Michael Hardt, Negri would exchange the 'encounter with the complexities of reality' for an 'adventure of reason' in which the tendency was flattened further into the pure immanence and positivity of communism.[11]

Deviations of the Tendency

In a case of unlikely bedfellows, Alain Badiou, in his 1982 work *Theory of the Subject*, also makes recourse to the method of the tendency:

> To the logic of the trajectory, which the structural dialectic comes up against and which announces the new only in the retroactive operation of its *mise-en-scène*, we oppose the logic of tendencies, of currents, of vanguards, wherein that which is barely at its birth, though placed and subjected, links up with the most terrible force of the future.[12]

Badiou's presentation of a contrast between the 'logic of tendencies' and a quasi-structuralist 'logic of the trajectory' is cast in surprisingly Lukácsian terms – considering that they are not usually seen as compatible figures. Badiou's comment that in the logic of the trajectory '[t]ime is extinguished by space' (108), could easily be mistaken for a quotation from Lukács.

Badiou identifies a deviation intrinsic to the logic of tendencies, which is that practised by 'the dynamicists' who 'posit ... the multiplicity of variable intensities' and 'who believe in the insoluble tendency.' (209) These thinkers, and Badiou obviously has in mind Deleuze and Guattari, emphasize the *priority* of the flowing tendency over any objective moment. In Badiou's brilliant piece of diagnostics: '[t]he asymptotic perspective of flight makes of the empiricist a wandering materialist, a vagabond philosopher of natural substances. Ignorance of the mirror turns the empiricist into the mirror of the world.' (209) Badiou's contention is that in their haste to depart from the 'static' or reified forms of capital's logic of economic and political places the dynamicists, ironically, end up *reflecting* the accumulatory and accelerative logic of capital.

In this way Badiou produces a critique of accelerationism, as a 'vagabond' method that tries to accelerate and rupture with the

capitalist world, while falling back into it. The accelerationist believes in a possible fusion with 'the insoluble tendency' to produce a new immanent rupture. Badiou's answer to this problem is that we have to zigzag between the logic of trajectories and the logic of tendencies so they each correct the other. Those who emphasize a static logic of the trajectory and the necessity of patient analysis of the world as it is prevent us from rushing into revisions of our method that would leave it detached from reality. At the same time the dynamicists provide a necessary sense that we must take risks with the method and cannot simply follow the contours of reality. Although not consistently developed in his later work, Badiou's suggestion provides a useful means for 'balancing' between those sorts of pessimistic analyses which suggest an all-encompassing capitalism that always allocates people to their ideological place (as we find in certain moments in Althusser, Adorno, and contemporary value-form theorists like Moishe Postone), and those optimistic analyses that always stress 'resistance comes first' and the imminent arrival of a new era of flux and freedom (precisely Negri, Deleuze and Guattari, and even certain moments in Jacques Rancière).

Badiou's criticism of Deleuze and Guattari and his suggestion that we practice a method of the tendency that does not embrace the perspective of 'flight' makes it no surprise that he should later vehemently reject Negri's own variant of accelerationism:

> As is well known, for Negri, the Spinozist, there is only one historic substance, so that the capitalist empire is also the scene of an unprecedented communist deployment. This surely has the advantage of authorizing the belief that the worse it gets, the better it gets; or of getting you to (mis)take those demonstrations – fruitlessly convened to meet wherever the powerful re-unite – for the 'creation' and the 'multiform invention' of new petit-bourgeois proletarians.[13]

Badiou notes what we earlier gestured towards: the tendency is taken by Negri as the *immediate* fusion of reason and reality in one Spinozist 'historic substance'. What is lost is any nuancing of the tendency, any real sense of the tendency as riven by contradictions, tensions, and reversals. The implication of such a reading of the tendency is that crisis is not to be reined in by the rationality of socialist or communist planning, but exacerbated by new forms of flight and flow – truly we haven't seen anything yet.

Perhaps the best indication of the fatality of Negri's 'mirroring' of capital is his constant stress that the revolutionary movements of the 1960s and 1970s were *successful*. Negri argued that the recuperation of the revolutionary impulses of the 1970s was not a sign of defeat, but of actual communist success lurking beneath the rotted carapace of capital. One more effort and the fetters of capital would be shaken free releasing the communist content within. This perpetual chant can crescendo at the onset of any crisis. Paolo Virno, in contrast, and rightly in my view, argued that the defeat of the revolutions of the 1960s and 1970s led to a 'communism of capital'; rather than a hyper-capitalism leading to communism, instead capitalism recuperated and redeployed communist elements (abolition of wage labor, extinction of the state and valorization of the individual's uniqueness) for its own purposes.[14] Negri, in contrast, magically parlays defeat into victory.

Through a Glass Darkly

Of course the criticism that Negri's theorization of the multitude is a 'mirror of capital' is not particularly original. My concern is not simply to point out the possible confusion of a supposedly communist apocalypse with an actually capitalist apocalypse. Instead, another, more important, irony is at work in this apocalyptic accelerationism. Gopal Balakrishnan has recently raised the more classical form of the tendency by returning to Marx's

speculations about the tendential *limits* of capitalism. Deleuze and Guattari had argued that Marx's contention that '[t]he *real barrier* of capitalist production is *capital itself* did not so much indicate that capitalism was doomed by its own limits of accumulation, but rather that this barrier should be smashed by the radicalization of capitalism's deterritorializing tendencies. Balakrishnan, instead, returns to the implied meaning of Marx's barrier metaphor that capitalism actually 'undermin[es] the original sources of all wealth'.[15] He notes that the 'acceleration' of capitalism since the 1970s, especially its technological developments of new cybernetic production forces, did not indicate some 'exhilarating new cultural condition' but rather '[c]apitalism's culture became an organized semblance of world-historic dynamism concealing and counteracting a secular deceleration in "the real economy".'[16]

Contemporary accelerationism is predicated on economic deceleration – there is a disjuncture, or even inversion, between the superstructure and the base. The 'mirror' of accelerationism is, as in Marx's (1845) famous metaphor of ideology as *camera obscura*, in fact an 'upside-down' image of 'historical life-processes.'[17] Although claiming to track the tendencies the analyses of the accelerationists took appearance for reality, or to put it in more precise Marxist terms could only grasp the 'real abstractions' of the capitalist form of value. While these 'real abstractions' truly are real, they shape and determine the forms of value, they lack the dynamism that accelerationists detected, and which such forms had, of necessity, to project. This is what makes Deleuze and Guattari's analysis of capital as an axiomatic machine or virus of deterritorialization at once so resonant and so problematic.

Balakrishnan is amusingly scathing about the supposed technological and economic achievements which might be thought to give material substance to these speculative flights:

the innovations of this period of capitalism have powered transformations in the *Lebenswelt* of diversion and sociability, an expansion of discount and luxury shopping, but above all a heroic age of what was until recently called 'financial technology'. Internet and mobile phones, Walmart and Prada, Black-Scholes and subprime – such are the technological landmarks of the period.[18]

Certainly Balakrishnan indicates the danger of a tendential accelerationism taking a particular projected tendency of capital, or even the fantasmatic self-image of capital, for its reality. Of course, part of the 'drive' of contemporary accelerationism is to overcome this inertia in the name of *Real* forces of acceleration.

It is this fact that accounts for the persistence of accelerationism and its hyperbolic verve. Against 'Walmart and Prada, Black-Scholes and subprime' it restates the promise of the 'insoluble tendency' of the development of forces, both technological and human. These are melded in the concept of the 'cognitariat', the 'new' cognitive and affective workers who fuse together the capacities of the human and technological in an immanent matrix. Instead of this fusion I am arguing for a necessary detachment from this image of dynamism in which history is on our side. The method of the tendency needs correction in terms of charting more closely the forms and forces of contemporary labor and modes of struggle, rather than an apocalyptic assertion of some final unveiling of forces (the Greek meaning of the word 'apocalypse' is the 'lifting of the veil'). Apocalyptic accelerationism reverses T.S. Eliot's assertion that the world will not end in a bang, but a whimper. The promised bang, however, has not materialized in quite the right form.

6

Terminal Acceleration

> When I talk about shit, it is hardly a metaphor: Capitalism reduces everything to shit, that it to say to the state of undifferentiated and decoded streams out of which everyone has to take its part in a private mode and with a sense of culpability.
> Félix Guattari[1]

Things are shit. Terminal accelerationism, however, sees this shit as what Alain Badiou calls 'nourishing decomposition';[2] as the chance to break through the sterility of a failed capitalism and leap into a new future. I want to analyse, or anal/yse, this 'excremental vision' as one of the signature forms of contemporary accelerationism. Rather than the relentless positivity of thinkers like Deleuze and Guattari, or Negri, here the path of acceleration lies in the negativity and nihilism of capitalism. We've already seen that Jean Baudrillard is one of the key figures of this form, but I want to return two earlier moments to track the convergence of the negative and the apocalyptic. These are the 1930s work of Georges Bataille and Jean-Luc Godard's 1967 film *Weekend*. If the car was the model of modernist speed then Godard's *Weekend*, with its famous single tracking shot of a traffic jam lasting over eight minutes, suggests the terminus of that model. The film also bears the intertitle 'A FILM FOUND ON A SCRAP-HEAP', which we could rephrase as 'A FILM FOUND ON A SHIT-HEAP', considering its staging of a veritable scatological apocalypse.

Godard's film makes an obvious reference to Georges Bataille. The image 'anal/yse' appears before Corinne's monologue – a fantasy, or nightmare, or reality – which describes sex scenes that deliberately mimic the anal eroticism of Bataille's 1928 novel

Story of the Eye (and which makes it to wikipedia's cultural references for the film). We could also add the more esoteric reference that 'Emily Brönte' appears as a character in the film and one of the 'case studies' in Bataille's *Literature and Evil* (1957) is dedicated to her work. At a more general level we could say that Godard develops Bataille's 'heterological' vision, which Bataille articulated in the 1920s and 1930s, of 'an irruption of excremental forces' that void value.[3] In Bataille's excremental Marxism the revolution erupts from the 'materialist bowels of proletarians' (35), while class struggle, for Bataille and Godard, is an excremental apocalypse in which everything turns to shit.

This shit forms a site of equivocation and reversal: from an anal capitalism of crisis and waste to a revolution that will accelerate beyond the 'limited' waste capitalism produces, which is always subordinate to value. In this way accelerationism can weave together the apocalyptic possibilities of the productive forces and the apocalyptic possibilities of destruction. If capitalist crisis operates, as the Austrian economist Joseph Schumpeter argued, by periodic bouts of 'creative destruction',[4] then this form of terminal accelerationism aims to exceed capitalism on its own ground.

Wallowing in the Mud

In an article of 1929 titled 'The Language of Flowers' Bataille writes, apocryphally as it unfortunately turns out, of

> [t]he disconcerting gesture of the Marquis de Sade, locked up with madmen, who had the most beautiful roses brought to him only to pluck off their petals and toss them into a ditch filled with liquid manure – in these circumstances, doesn't it have an overwhelming impact? (14)

The impact of Sade's gesture for Bataille is that it confirms his invocation of 'base materialism' as that which returns to

excrement to void beauty and value. This is why Bataille would chide Nietzsche for being 'altogether incapable of wallowing in the mud' (39). Unlike Nietzsche's attempt to constitute the possibility of the overman (*übermensch*), Bataille's vision was of the 'underman': of dragging 'man' down into the excrement. In the 1920s and 1930s Bataille developed what he would later call a 'general economy', which 'founded' itself in the excremental, the perverse, and all the elements that could not be coordinated with utility, and which ruptured the restricted economy of capitalism. I don't think it is a coincidence that he should develop this theory at the same time capitalism entered into worldwide depression after the Wall Street Crash of 1929. This 'heterology' functioned as a 'cloacal' critique that targeted the stabilizations of value accumulation and labor. Bataille's materialism not only ruptured the image of a stable economy, but also the image of stable matter. For Bataille materialists were too-often guilty of turning matter into a 'dead God' by simply reversing the place of matter from below to above. In contrast Bataille argued that the disruption of 'senile idealism' required we see matter as unstable, active, and excessive (15). We have to drag all ideals and values down into the mud.

Of course, as Jean-Joseph Goux points out, Bataille's economy of excess might have had traction on the asceticism of the Protestant ethic of a capitalism committed to accumulation but it seems to have a strange congruence with a 'postmodern' capitalism of excess.[5] Even Bataille's proximity to the Wall Street Crash signals this ambiguity, as capitalism enters into its own voiding and destruction of value only then to restart in a destructive war economy. If we read the life story of Don Simpson – the producer of so-called 'high concept' films during the 1980s and early '90s, such as *Beverly Hills Cop* (1984) and *Top Gun* (1986) – we can see how a transgressive world view conforms to capitalism's fantasmatic self-image as liberatory and excessive.[6] Simpson's punishing regime of excess – from drugs

and prostitutes, to exercise and plastic surgery – involved him working on the very materiality of his body to make himself the 'perfect' capitalist subject. We could also turn to the more quotidian fact that those abandoned by capitalism, as 'surplus humanity', often live, literally, in shit.[7] Instead of the excremental and perverse setting out some alternative space to capitalist modernity it becomes coded within it, as its inherent and licensed transgression, and hence reconnected to value production but at the level of 'pure' speculation and excess. The so-called 'sound investment' can turn into excrement, but also excrement or waste can suddenly become a speculative resource.

The impasse of Bataille's critique is not only that it has been outpaced by a 'cloacal' capitalism, a capitalism that thrives on excess and waste. The more damaging problem is that it conceives this excess or waste as the site of a new production, which hardly seems to break with capitalism. This is an inverted or negative productivism, which accelerates destruction to a 'higher' level of solar excess – a terminal acceleration. This productivism makes it hard to see how Bataille can be used, as Baudrillard wished, to shatter the 'mirror of production'.[8] Bataille is equivocal. While it's true he can be read as hymning a new form of production, his work also insinuates a crisis within production. It is not so much that Bataille is offering an alternative principle of waste, but that his undermining production from within, eroding or sapping its capacity. His use of the figure of the 'rotten sun' suggests this equivocal undermining of solar excess by dragging down excess into a rotten base matter (57–58). Bataille attempts the impossible task of thinking elevation together with the sudden downward fall.

Bataille's line of flight along the excremental demonstrates the difficulty of the attempt to find an absolute resistance to accelerationist and productive dynamics. If we erect a principle of waste then we can find that principle reversed into a 'nourishing decomposition'. Bataille's 'solution', which doesn't exactly solve

the problem in the traditional sense, is to suggest a reversible moment that lies within any 'productive' discourse or practice. In this moment the negative and positive can suddenly, and catastrophically, shift places. The difficulty remains, however, of extracting this possibility from the shifting 'dynamics' of contemporary capitalism.

Barbarism or Barbarism?

Godard's *Weekend* concerns a bourgeois couple, Roland and Corinne, who are driving to Corinne's father to collect her inheritance. Both have secret lovers, both are plotting to murder each other, and both are happy to murder Corinne's father if necessary to claim the inheritance. Their journey through France rapidly descends into anarchy as the bourgeois social-order falls apart around them. Here the excremental is revolutionary – the apocalyptic crisis of the bourgeoisie. Godard casts this crisis in the satirical form of cannibal revolutionaries – the 'Seine-et-Oise Liberation Front' (FLSO) – who dominate the closing sequences of the film. Quasi-hippy revolutionaries, dressed in parodic Native American costume, the FLSO provide a literalization of the metaphor of ingestion, not so much digging the grave of the bourgeois world as consuming and voiding it.

In fact, as Godard's film registers, this 'excremental vision' is split: we have the revolutionary anality of Bataille, in which the heterological forces open a reenchantment and resacralization of reality, but also the anality of capitalist production, with its cycles of digestion and voiding in 'creative destruction'. Godard reproduces explicitly the tension we noted in Bataille, in which revolution and creative destruction intertwine and merge in new forms of destructive consumption. In fact the cannibal is at once the irrecuperable figure of extremity *and* the figure of an auto-consumptive capital.

Norman O. Brown's *Life against Death* (1959) analyses this split vision in his, now contested, reading of Jonathan Swift. For

Brown, Swift's 'excremental vision' reveals the anality of culture and the psyche. In Brown's words, 'for Swift [scatological imagery] ... becomes the decisive weapon in his assault on the pretensions, the pride, even the self-respect of mankind.'[9] And yet the revelation by Swift of the excremental core that wrecks human dignity is also the historical revelation of the anal economy of capitalism itself. Eli Zaretsky notes: 'Capitalism at root, Brown argued, was socially organized anality: beneath the pseudo-individuated genitality of early modern society, its driving force was literally the love of shit'.[10] The chapter on *Weekend* in the discussion between Kaja Silverman and Harun Farocki on Godard is titled 'Anal Capitalism'.[11]

If the excremental is under the sign of the sacred then it displays the typical equivocation of the sacred: revolutionary or bourgeois, terminal regression or rebirth? If the 'driving force' of capitalism is 'the love of shit' then this 'driving force' is appropriately figured in the equivocal status of the car, which in *Weekend* is both 'treasured commodity' and 'worthless junk'.[12] The 'weekend' break from production leads to the heterological space of stasis, in which production is reversed into voiding; the traffic jam is the blockage of this driving force, the indigestible moment of failed flow and the accumulation of the excremental. The famous long tracking-shot of the traffic jam, as Brian Henderson points out, finds its future echo in the tracking-shot of the car production-line in *British Sounds* (1970).[13] Again Godard plays on the reversal of production and destruction, production and anti-production, value and waste. He injects, as Bataille did with his thinking of instability, an oscillation into this vision of excremental vitalism.

The equivocation of the 'driving force' of capitalism – the question whether this anal economy of incorporation, digestion, and excretion that Bataille traces can be derailed into an ecstatic and apocalyptic voiding – is redoubled in the moment of the scatological apocalypse. We equivocate on the waste of a decomposing culture. Does Godard offer us 'a nourishing decomposition', are

we merely mired in the scrap-heap? In Swift's words, will we find 'Such gaudy Tulips rais'd from Dung'?[14] *Weekend* implies is that we no longer have socialism or barbarism, but barbarism *per se*; but it is this barbarism that seems to be the only way to socialism? Harun Farocki argues that: 'there is the suggestion that under the thin veneer of this "civilization" beats the heart of a more affectively vital "barbarism."'[15] For Godard's 'revolutionaries', '*We can only overcome the horror of the bourgeoisie by even more horror.*'[16] This could well be the motto, *avant la lettre*, of terminal accelerationism.

The lesson of *Weekend*, which is why it resonates in the present moment, is that an excremental vitalism emerges in terminal crisis. In Bataille's formulation, the revelation of 'a disagreeable and terminal stagnation' destroys 'the prestige of industrial reality'.[17] This is the promise that, as Robin Wood puts it, '*Weekend* is not about the end of the world – it is simply about the end of *our* world.'[18] In a rather touching remark, Wood continues: 'The film postulates, rather convincingly, the irrelevance, uselessness, and ultimate disintegration of everything I have always believed in, worked for, and found worth living for, and I don't think I can be unique or even unusual in this.'[19] The apocalypse is limited to the end of the bourgeois world, and out of the shit the rebirth of a new vital order.

The horror of vital barbarism predicts a new impassioned future. This chimes with the remark of the nineteenth-century socialist William Morris, after reading Richard Jefferies apocalyptic novel *After London* (1885), that:

I have no more faith than a grain of mustard seed in the future history of "civilization", which I *know* now is doomed to destruction, and probably before very long: what a joy it is to think of! and how often it consoles me to think of barbarism once more flooding the world, and real feelings and passions, however rudimentary, taking the place of our wretched hypocrisies.[20]

Barbarism is regeneration. The difficulty is that Godard repre-
sents the 'new world' as one of stasis and drift and not a world of
'real feelings and passions'. The cannibal revolutionaries feast on
the remains of the old order, literally, and live lives that are
hardly passionate.

While the promise is that one world will end in horror to give
birth to a vital and passionate new world, presumably without
horror, it seems unlikely, in Godard's film, that horror will
peaceably disappear. Although *Weekend* appeared just before the
events of May '68, which would reinvigorate 'the passion for the
real', in Godard's film this revolutionary passion takes the
terminal form of cannibal extinction. His cannibal revolutionaries
are studied hippie primitivists, who play drums, rape their
captives, and are served their meals by the cook in blood-stained
apron. The dialectic in the revolutionary 'passion for the real'
between voluntarist vitalism and historicist confirmation is
ruptured in Godard's film through a regression. In this regression
'vitality' detaches itself from history and pulverizes history into a
mythic space of social degree-zero and auto-consumption.

If capitalism is *all* shit, if we have an 'anal capitalism' that
levels all into general equivalence, then the end of everything is
required in a final voiding. The apocalyptic tone is required prior
to some 'future', a full decomposition to consume that rotting
culture. Godard, as Silverman notes 'launches an extended
assault upon all forms of abstraction.'[21] With abstraction, itself
the organization of levelling and equivalence through value,
voided, we have what appears to be another abstraction of
absolute barbarism. This voiding and levelling of abstraction
takes its own revenge, as a kind of capitalist nihilism or
exhaustion that turns the film once again into shit. The signs
equivocate again, and the 'liberation' of the anal, of the 'excre-
mental forces', is, to again quote Silverman, 'not the utopian
sexual liberation hailed by Hocquenghem thirty years ago, but
the catastrophic end of all singularity. What we might call "anal

capitalism" decrees the commensurability of "male" and "female," but only by consigning both, along with *Weekend* itself, to the cosmic scrap heap.'[22] The apocalypse reveals then not another revolutionary order, the film as gate to May '68 which redeems its hippy-cannibal revolutionaries into the 'good hippies' of libidinal revolt, but watched again at the point of the voiding of the capitalist order in crisis, seems also to reveal a terminal levelling of capital itself.

Does the equivocation of satire have to be met with a full politicization to escape the relentless dialectic of reversal between satire and object? For Godard *Weekend* was his last film before the collective experiment of political filmmaking the Dziga-Vertov Group. Writing in 1973, Thomas M. Kavanagh argues Godard's turn to explicitly political and didactic cinema as the only possible response to the fact that the bourgeoisie adored *Weekend*.[23] The commercial and critical success of *Weekend* would lead Godard to depart for the austerity and collective practice of his explicitly political filmmaking of the early 1970s.

Recuperation and re-digestion; an anal biopolitical economy à la Pasolini's film *Salo* (1975) beckons. The irrecuperable 'foreign body' becomes an object of *jouissance*, of self-disgust that returns to bourgeois narcissism. Revolution itself is circular: 'There is even the familiar suggestion, rendered concretely in the film in terms of similarities and parallels in their rituals – eggs and fish between girls' thighs – that the revolutionary society will be another formulation of the murderously bourgeois one we knew already.'[24] Godard's escape out of this circle of consumption was an indigestible political austerity that could not, he felt, be capitalized on.

And yet the collapse of Godard's political certainties and those of his critics re-locate the satire or parody of *Weekend* in our moment: the *Weekend* of crisis, the bursting of the bubble, abandonment of house and car as debt-loaded 'hostile objects'.[25]

Excremental or cannibal hostility now shapes the decomposing culture of capitalism. The impasse of Godard's film was to be saved through political praxis, but the decomposition of capitalism and of that praxis makes the 'levelling' of *Weekend* if not 'radically funny', at least necessary again. In this way it is the terminal document of negative accelerationism. It is at once its most extreme satiric form, but tips over into the abstract voiding that figures our moment.

7

Emergency Brake

Fredric Jameson, reflecting on the contemporary moment, comments that:

> we may pause to observe the way in which so much of left politics today – unlike Marx's own passionate commitment to a streamlined technological future – seems to have adopted as its slogan Benjamin's odd idea that revolution means pulling the emergency brake on the runaway train of History, as though an admittedly runaway capitalism itself had the monopoly on change and futurity.[1]

In light of the persistence and resurgence of accelerationism Jameson's characterization of the contemporary left is dubious. Acceleration hasn't gone away, and Jameson's own retooled productivism is part of a 'passionate commitment to a stream-lined technological future' that persists and even increases at our moment of crisis.

I want to pause on Jameson's reference to Walter Benjamin's 'odd idea' that revolution might be an act of deceleration, inter-ruption, or stopping the 'runaway train of History'. This obviously suggests a counter to accelerationism. The reference is to the notes for Benjamin's 1940 essay 'On the Concept of History', where he writes: 'Marx says that revolutions are the locomotive of world history. But perhaps it is quite otherwise. Perhaps revolutions are an attempt by the passengers on this train – namely, the human race – to activate the emergency brake.'[2] For Jameson, obviously, this conception is an 'odd idea' because it is a failure to measure up to Marx's own embrace of capitalism, and capitalist production, as the condition of revolutionary change.

Benjamin's 'odd idea' had an explicit context. This was the critique of German Social Democracy, especially in Thesis XI of 'On the Concept of History', where Benjamin chided it for 'moving with the current'.[3] The conformity of Social Democracy to the ideology of progress and acceleration, and not least techno-logical progress, meant that it was unable to grasp the dynamic of fascism and unable to critique capitalism effectively. Beyond this historical argument I want to suggest that there is something more to Benjamin's 'odd idea', both then and now.

If we return to Benjamin's work we can see that it is closely engaged with questions of acceleration and production, especially in his dialogue with Bertolt Brecht. After they met in the late 1920s Brecht and Benjamin engaged in an intense debate over how to subject capitalist production to 'refunctioning' (*Umfunktionierung*).[4] While this took place in a very different historical context – the failure of the revolutionary wave after 1917, inflation in Germany and global capitalist crisis, and the rise of fascism – the Brecht/Benjamin debate resonates in our moment. Invocations of Weimar, the 1929 Crash, and anxieties of incipient fascism or war, have become familiar tropes in commentary on our crisis. This is a rather speculative connection, but Brecht and Benjamin offer resources to interrupt a capitalism locked-into crisis and destruction.

Over the Dead Body of Capitalism

Gershom Scholem suggests that Brecht entered Benjamin's life, in 1928, as an 'elemental force'.[5] We can read this 'force' as Brecht's insistence on the reworking of production. When Benjamin came to know Brecht in the early 1930s, Brecht was articulating his critical practice of cultural and political production to come to terms with the crisis-ridden and destructive effects of capital, in the wake of 1929 and the experience of German inflation.

A key statement is Brecht's poem 'The Proletariat Wasn't Born in a White Vest' [*Das Proletariat ist nicht in einer weissen Weste*

geboren] (1934). The poem presents a litany of capitalist decline, before concluding: 'oh, on that day the proletariat will be able to take charge of a /culture reduced to the same state in which it found production: in ruins.'[6] The proletarian is not the 'clean' modernist new man, but is willing to get his or her hands dirty. This is the only class able to grasp and resolve the 'dirty' ruins of capitalism. Alain Badiou argues that Brecht's poem is founded on the 'essential thematic [that] the new can only come about as the seizure of a ruin. Novelty will only take place on the basis of a fully accomplished destruction'.[7] The proletariat dirties itself with completing the work of destruction on capitalism, but in the service of a new communist production. The ruin of capital is what Badiou calls a 'nourishing decomposition'.[8]

Brecht is suggesting the re-use of the ruins of capitalism, and this can take provocative forms. Like the Soviet avant-garde Brecht is not afraid to engage with the worst elements of capitalism:

Behaviourism is a psychology which begins with the needs of commodity production in order to develop methods with which to influence buyers, i.e., it is an active psychology, progressive and revolutionizing kathode (*Kathoxen*). In keeping with its capitalist function, it has its limits (the reflexes are biological; only in a few Chaplin films are they already social). Here, too, the path leads only over the dead body of capitalism, but here, too, this is a good path.[9]

Brecht's 'refunctioning' turns on the most extreme forms of capitalist technology as the means to find a 'good path' over the 'dead body of capitalism'. We have to traverse what Benjamin calls 'the dirty diapers of the present.'[10] Again, what is crucial here is not just the 'dirt' or waste produced by capital but, as we saw with terminal accelerationism, the need to dig into this dirt to produce the new.

In his 'Conversations with Brecht' Benjamin mentions 'the destructive aspect of Brecht's character, which puts everything in danger almost before it has been achieved.'[11] That Brecht is one of the models for Benjamin's essay 'The Destructive Character' (1931) is, by now, a commonplace.[12] Brecht's 'destructive character' provoked Benjamin to think about destruction and production. While the Benjamin essay can be taken as a manifesto for destruction, it is also a manifesto for the retooling or refunctioning of production. 'The Destructive Character' destroys to clear the way for something new. This moment of production, however, is predicated on interruption. In this chapter I want to trace this thinking of interruption in Brecht and Benjamin as a complication of any resort to accelerationism.

The Slob

Irving Wohlfarth has noted that Benjamin's destructive character is 'the efficient executor of an eviction order.'[13] What kind of eviction order? I want to suggest this is an eviction order executed by a slob. In Fredric Jameson's 1998 book on Brecht he poses the Brechtian energies of production and praxis against the stasis of our opaque and financialized postmodernism. Reflecting on Brecht's pre-Marxist work *Baal* (1918) Jameson identifies the character Baal with the figure of the slob:

> These are the slobs of literature rather than its zombies or living dead: creatures of physical and vestimentary neglect, satyrs, dirty old men, and the like, they are the archetypes of appetite, surging up from popular culture (rather than, as with supreme villains and manifestations of evil, from the lettered).[14]

This figure is destructive, in the sense, as Jameson says, that they 'erupt and break the furniture'.[15] Jameson notes that: 'The Brechtian aversion to respectability in general is richly documented in the early works – with *Baal* as its virtual allegory:

the Marxian turn is thereby able to tap those "antisocial" energies for a new and more *productive* engagement with the negative.'[16] So, the seemingly 'purely' destructive slob does not simply disappear in Brecht's embrace of Marxism and production. In fact the slob persists within the moment of production as a moment of interruption.

Brecht's short story 'North Sea Shrimps', probably written around 1926, and subtitled 'or the modern Bauhaus apartment', is an allegory of the slob's interruption.[17] It tells of the visit of Müller and the narrator to the apartment of their wartime friend Kampert. Kampert is committed to a life of luxury after his experiences in the trenches of the First World War and, having married into money, fulfils his dream. The apartment is now perfect Bauhaus, whereas before: 'It was two plain bourgeois rooms. You know the kind of thing, cramped to start with and then stowed to the gunwales with furniture.' (79)

The all-lilac room, the delicate blinds, and the lack of pictures, drive the narrator, and particularly Müller, to distraction:

What irritated Müller was the flat. He was completely wrong about this. It was a very pleasant flat, not at all ostentatious. But I think Müller just could not stand the carefully contrived harmony and the dogmatic functionalism of it any longer. (82)

Although Müller has brought a present of North Sea shrimps he sends out Kampert on a false errand to buy some, and then proceeds to redecorate. He violently rearranges the furniture, tears down the blind, and sticks up magazine pictures on the wall with sugar water. The narrator concludes, 'Man is like a terrible tornado, creating the grandiose multiplicity and admirable disharmony of all creation out of an almighty pile-up of patent American chaise-longues, common washbasins and old, venerable, magazines.' (84)

This short story disrupts Benjamin's later invocation of the

glass architecture of Scheerbart and Bauhaus in 'Experience and Poverty' (1933) as the gesture of 'erasing the traces' called for by Brecht.[18] The creation of 'rooms in which it is hard to leave traces',[19] is exactly what Brecht's 'destructive slob' is reacting against, with Müller having 'this longing for all that was most ill-matched, most illogical and most natural.' (85) While Benjamin's version of the destructive character wipes away the traces of those who want comfort, Brecht's destructive slob makes his space comfortable by putting his trace on things. The destructive 'baseness' of Müller, his lumpen status, interrupts the clean modernist space. He actively turns the new into ruins, interrupts the new, to create something that is not exactly productive, but rather illogical.

Angelic Locomotives

My second scene of interruption is from one of Walter Benjamin's radio talks for children, given in 1932, on 'The Railway Disaster at the Firth of Tay' ('Die Eisenbahnkatastrophe vom Firth of Tay').[20] As the title suggests the central subject of the talk is the railway disaster of 28 December 1879, when a passenger train of six carriages and two hundred people was lost after plunging into the Tay, when the iron bridge it was passing over collapsed during a fierce storm. Benjamin does not begin with the disaster, but rather with the early technologies of iron working and train construction and with what he calls, in his essay on Eduard Fuchs, the 'defective reception of technology'.[21] This 'defective reception' turns, in part, on acceleration, as Benjamin reports the view of the medical faculty at Erlangen suggesting that the speed of rail travel would lead to cerebral lesions, while an English expert suggested that moving by train is not travel but simply being dispatched to a destination like a package. Perhaps neither could foresee the current British train system…

In describing the disaster Benjamin quotes from a poem by Theodor Fontane, not the renowned poem by William Topaz

McGonagall – renowned for being terrible. This is the first stanza of the McGonagall:

> Beautiful Railway Bridge of the Silv'ry Tay!
> Alas! I am very sorry to say
> That ninety lives have been taken away
> On the last Sabbath day of 1879,
> Which will be remember'd for a very long time.[22]

Benjamin reports that when the accident occurred the storm was raging so severely it was not evident what had happened. The only sign were flames seen by fishermen, who did not realize this was the result of the locomotive plunging into the water. They did alert the stationmaster at Tay, who sent another locomotive along the line. The train was inched onto the bridge and had to be stopped a kilometre out, before reaching the first central pier, with a violent application of the brakes that nearly led to the train jumping from the tracks: 'The moonlight had enabled him to see a gaping hole in the line. The central section of the bridge was gone.'[23]

The brake is a figure of interruption, and this foreshadows its later use in 'On the Concept of History'. While one catastrophe has already occurred, in which two hundred people have lost their lives, the act of braking prevents, although only barely, a second catastrophe. We can place this consideration of the locomotive, speed, and the malignancy of technology, alongside Benjamin's remark in the essay on 'Eduard Fuchs' that:

> The disciples of Saint-Simon started the ball rolling with their industrial poetry; then came the realism of a Du Camp, who saw the locomotive as the saint of the future; and a Ludwig Pfau brought up the rear: 'It is quite unnecessary to become an angel', he wrote, 'since the locomotive is worth more than the finest pair of wings.'[24]

This angelic locomotive, which rushes into the future and into destruction, can be paired with Benjamin's famous invocation of the *Angelus Novus* or Angel of History in 'On the Concept of History' (1940), which is turned to the past and contemplates the wreckage of history.

The 'Angelic Locomotive' is, therefore, the sign of acceleration to the point that indicates that the 'energies that technology develops beyond their threshold are destructive.'[25] The point here is that we can't simply accept technology as it is, but the 'refunctioning' of technology depends on the interruption of capitalist acceleration. Benjamin reiterates this point in his essay 'Surrealism: The Last Snapshot of the European Intelligentsia' (1929), where he criticizes the surrealists for their 'overheated embrace of the uncomprehended miracle of machines'.[26] Such a characterization speaks, obviously, to the currents of accelerationism. Benjamin is poised in a tense debate not only with Brecht, but also with his own earlier desire to wrest the forces of production for revolution (which we discussed in Chapter 1).

Revolutions per Minute

Both Brecht and Benjamin adopt positions that can, at times, loosely be described as accelerationist. I've tried to probe the fact that they also disrupt and interrupt the accelerationist fantasy of tapping into the capitalist forces of production. What I've suggested is that the image Jameson offers of 'a streamlined technological future' as the key to revolutionary change is precisely what they put into question. The result is not simply some nostalgic or pastoral vision, but rather an interruptive politics that refuses to treat capitalist production on its own terms. Instead, Brecht and Benjamin are attentive to the destructiveness of the productive forces, and particularly those that have gone off the rails.

Benjamin's registering of destruction, and its equivocation, suggests exactly that heterogeneity of time that will find its

formulation in 'On the Concept of History' (1940). Homogenous empty time is the time of the train on the tracks, which can speed up and slow down. The emergency brake of Benjamin's metaphor for revolution is not simply the stopping of a train on the smooth tracks of progress. Rather, as with the metaphor of the angel of history, it suggests that the train tracks into the future are being laid immediately in front of the train. In fact, the anecdote of the Tay Bridge disaster suggests that the emergency brake is applied precisely due to the *derailing* of the train, and threatens another catastrophic derailing. The 'rails' of history accelerate us to disaster if we are not aware of the destructive side of the dialectic of production.

The irony, as Benjamin's notes make clear, is that the desire for acceleration on the tracks of history breeds passivity before the productive forces:

> Once the classless society had been defined as an infinite task, the empty and homogeneous time was transformed into an anteroom, so to speak, in which one could wait for the emergence of the revolutionary situation with more or less equanimity.[27]

The idea of the tracks stretching into the future leaves revolution as a receding moment – the station we never quite arrive in. The result, contra to the revolutionary intervention, it is the constant stoking of the train, i.e. the capitalist productive forces. This is another instance of accelerationism, which either tries to actively increase the speed of capital, or simply becomes the passenger on the train, allowing the constant destruction of living labor at the hands of dead labor to do the work.

The conclusion is that the emergency brake is not merely calling to a halt for the sake of it, some static stopping at a particular point in capitalist history (say Swedish Social Democracy – which the American Republican Right now takes as

the true horror of 'socialism'). Neither is it a return back to some utopian pre-capitalist moment, which would fall foul of Marx and Engels's anathemas against 'feudal socialism'. Rather, Benjamin argues that: 'Classless society is not the final goal of historical progress but its frequently miscarried, ultimately [*endlich*] achieved interruption.'[28] We interrupt to prevent catastrophe, we destroy the tracks to prevent the greater destruction of acceleration.

The emergency brake is the operator of Benjamin's non-teleological politics of temporality, which aims to wrest the classless society from the continuing dialectic of production/destruction that is our constant 'state of emergency'.[29] Instead of accelerating into destruction, we have to think destruction as an intimate and on-going possibility. In the case of Brecht's slob we have a kind of anti-handyman destruction posed against the clean new. Here we rearrange and take apart the new in 'illogical' ways. Benjamin's interruption suggests a more definitive break (or brake) with the aim of production. The stopping of the angelic locomotive tries to jump the tracks of history, or jump out of the vision of history as infinite waiting for the revolutionary situation.

Inevitably this jumping of the tracks will produce something new – there is no simple way outside of production, as we have repeatedly seen. To interrupt acceleration(ism) is not to give up on the new. We can, instead, consider production as an interruption, as a series of experiments that have 'frequently miscarried'. This does not prevent the 'ultimately [*endlich*] achieved interruption' which would be the real condition of the new. Brecht and Benjamin's thinking of interruption is a thinking of intervention that not only stops acceleration, but also rethinks production and the very notion of 'productive forces'. The difficulty of applying the emergency brake does not mean that interruption should be abandoned.

Conclusion:
The Moving Contradiction

Communism is not radical. It is capitalism that is radical.

Bertolt Brecht

Lenin once described 'left communism' – the radical rejection of parliamentary elections and unions as sites of struggle – as an 'infantile disorder'.[1] I would describe contemporary accelerationism as a 'postgraduate disorder'. This is not just a reference to the subjective position of contemporary accelerationists, and neither is it mere name calling or ad hominem argument. I'm referring to the specific position of the postgraduate on the edge or cusp of the job market. The postgraduate possesses, usually, significant cultural capital, but they confront full immersion in the labor market fairly late in life. Of course, in the UK and US, student financing already forces them into a future life of debt servitude. Also, many are working, trying to get ahead or, more often, stay afloat. That said, this merely adds to the fact that the world of labor is confronted as one of future horror – endless and trivial. Accelerationism provides an answer by turning the horror of work into the *jouissance* of machinic immersion. We may face a life of labor, but we can try and face it 'kein Schmerz, kein Gedanke' – without feeling, without thought.

This is the immersive fantasy of work as site of repetitive libidinal acceleration, where the bourgeois ego is drowned in the icy waters of inhuman labor. While remarkably easy to criticize, such a vision recognizes a truth of the decomposition of contemporary capital. In particular, it is the collapse of the future as sustainable mode of life under capitalism, which accelerationism answers with an ersatz future in its place: retooled retro-70s futurism coupled to the frayed remains of capitalist 'dynamism'.

What could be an alternative? To pose this problem I want to

first consider the current attempts to put the brakes on accelerationism and contemporary restatements of accelerationism. Tracking between these two extremes I want to suggest that the traversal of accelerationism requires more than a simple rejection or the discovery of some (un)happy median. We have to tap and resist the incitement of desire that capitalism produces and which accelerationism mimics – the fantasy of immersion into Real forces of acceleration.

A Supposedly Fun Thing

The few scattered anti-accelerationist critiques of our present moment often seem to leave untouched the libidinal core of accelerationism. These alternatives seem tepid, or even reactionary – take Franco 'Bifo' Berardi's invocation of a politics of exhaustion that would 'become the beginning of a slow movement toward a "*wu wei*" civilization, based on withdrawal, and frugal expectations for life and consumption'.[2] This postmodern Taoism hardly enchants, and its expectation of sacrifice and escape seems to mock those paying for the current financial crisis. 'Frugal expectations' are what many of us already have, and such promises can hardly compete with offers of acceleration and excess. For this reason it is not surprising that accelerationism gains adherents uncomfortable with such re-treads of the usual political moralisms.

A more convincing version of the politics of deceleration has been given by Timothy Brennan, partly based on the slow slide of Cuba from its state as one of the last remaining 'actually-existing' forms of socialism to what, almost certainly, will be a capitalist future. In this strange hiatus or transition Brennan glimpses another possibility, in which the pleasure of socialism would be 'the pleasures of a slower pace'.[3] In particular, Brennan is willing to contemplate the problem of pleasure and to confront the incitements to desire of actually-existing capitalism with an alternative order:

The relative lack of commodities – at first glance anti-pleasure – would actually allow for a less extreme division of labor, freeing one from illusory 'choices' and the mental overload of advertising, as well as a greater (if not absolute) freedom from the tyranny of things.[4]

Pleasure is reconfigured, rather than abandoned to the frugalities of inhabited exhaustion. It is reconfigured in an alternative mode of choice, rather the compulsive exercise of 'choice' offered and demanded by contemporary capitalism. This reconfiguration of pleasure is a crucial element of any counter-accelerationist programme.

The recent restatements of accelerationism come explicitly against the background of ongoing financial crisis, the evident stasis of the world-system of capitalism, and the structural (mal)adjustments of Neoliberalism 2.0. The work of Alex Williams and Nick Srnicek has most explicitly tried to reinvigorate and retool accelerationism for our moment. They do so by reworking Nick Land's '90s vision, suggesting that we need to split speed from acceleration. Williams and Srnicek argue, on the one hand, that the endorsement of speed is the failing of 'traditional' accelerationism. This endorsement remains within the parameters of capitalism – it is a 'dromological acceleration' that proffers a 'fundamentally brainless increase in speed',[5] or even 'a simple brain-dead onrush'.[6] In contrast they suggest an 'acceleration which is also navigational, an experimental process of discovery within a universal space of possibility.'[7] We could speak of an accelerationist critique of accelerationism...

While this is a useful corrective to Landian excesses, it faces some conceptual and political problems of its own. Srnicek and Williams discuss High-Frequency Trading (HFT), in which new algorithmic computer instruments push trading below the limits of human perception and to the very limits of physics, but they cannot endorse it. Instead they find themselves in a rather

uncomfortable position in which HFT is taken as a new extreme:

> Where humans remain too slow – too fleshy – to push beyond
> certain temporal, perceptual, and quantitative barriers, HFT
> systems surge past, generating the fine nanoscale structure of
> modern financial markets, too intricate for the naked mind to
> observe.[8]

Yet, they insist, these systems are fundamentally stupid, unable to open out into a new conceptual space of possibility. HFT systems explicitly *do not* incarnate a new acceleration, but remain operators of dumb speed.

This leaves their accelerationism, unlike in Land's unequivocal endorsement of capitalist processes, ungrounded. Alternative possibilities of acceleration only open in a post-revolutionary space, which we get to in a much more traditional fashion: 'the tension fuelled dynamic between labor and capital incalculates a system-wide rupture.'[9] So, we have revolution as a result of the moving contradiction of capital and labor, then acceleration after. But even then it doesn't seem obvious why the opening of a space of possibilities necessarily entails acceleration, which implies forward momentum and advance of existing possibilities? Adorno remarked that 'Perhaps the true society will grow tired of development and, out of freedom, leave possibilities unused, instead of storming under a confused compulsion to the conquest of strange stars.'[10] While we can agree the end of capitalism would involve the loosening of new possibilities it is not self-evident that this accelerationism 2.0 can fully reconfigure the limitations or parameters of capitalism. In its nostalgia for space programmes and others forms of technological rush, it treads the same path of the accelerationism of speed. While Williams declares a push towards a 'future that is *more modern* – an alternative future that neoliberalism is inherently unable to generate',[11] it seems this remains within the parameters of the

modern as much as Land's vision did.

What we can trace between anti-accelerationists and accelerationists is a strange convergence on nostalgia – nostalgia for a vanishing possibility of socialist slow-down, itself a terminal slide away from socialism, versus a capitalist ostalgie that can only fill in our absent future with past dreams of acceleration. This is a painful irony for accelerationism, in particular, which stakes so much on its futurism. The nostalgia is a nostalgia for forces – a desire for something, anything, to generate enough energy and momentum to break the horizon of the present. It is important that this is a metaphysics of forces, and not force in the singular, to account for the dispersion and linking of different possible sites into a plane of immanence. Accelerationism is constructive, but the construct replicates the past in the guise of a possible future.

Impossible Labor

If accelerationism points to the problem of labor as the 'moving contradiction' of capital – both source of value, and squeezed out by the machine – then it tries to solve this contradiction by alchemising labor with the machine. I want to suggest that this is not a solution. We can't speed through to some future labor delegated to the machine, nor can we return to the 'good old days' of labor as 'honest day's work'. In fact, accelerationism indicates the *impossibility* of labor within the form of capitalism. This obviously doesn't mean labor does not take place, but it means labor can't and doesn't perform the function of political, social, and economic validation capitalism implies. The readiness of capitalism to abandon any particular form of labor at the drop of a hat, or at the drop of the markets, suggests that labor cannot carry the ideological weight it is supposed to.

In his study of workers in post-Apartheid South Africa Franco Barchiesi has detailed how, on the one hand, work is the condition of neoliberal citizenship, and how, on the other hand, it can't allow for true self-reproduction.[12] The privatization of

healthcare, insurance, transportation costs, home ownership, etc., leaves those 'lucky' enough to be in work unable to survive. While labor is essential for citizenship – if we think of the demonization of 'welfare scroungers', 'benefit cheats', and so on (and on) – it also never performs that function. Barchiesi notes that work under capital is always precarious, and this status isn't simply reserved for the 'precariat' – those in more obviously precarious work conditions that have emerged most strikingly in post-Fordist conditions. What is also crucial about Barchiesi's argument is that he notes that the revelation of this precariousness or impossibility of labor does not simply lead to left-wing political activation but, in the current ideological context, is as likely to lead to anti-immigrant and anti-welfare sentiments. Those struggling to survive as precarious workers are as likely to turn on others as they are to start new forms of support and struggle that recognize the impossibility of work.

This is, I think, one of the crucial conundrums of the present moment. Accelerationism tries to resolve it in machinic integration and extinction, which bypasses the problem of consciousness, awareness, and struggle in a logic of immersion. We are torn by the moving contradiction of capital into two broken halves that can't be put back together – neither able to go forward into the 'streamlined' future, nor return to the 'stability' of the Fordist past. There is no simple solution to this contradiction. What I want to suggest is that replication along the lines of nostalgia for images of capitalist 'productivity' is no way into the future. In fact the struggles over the state and condition of labor, even as impossible labor, have to be fought now.

My perhaps minimal suggestion is recognition of this contradiction is the first necessary step. This returns us to 'traditional' problems of how we might intervene and negate the forms and forces of labor that mutilate and control our existence. Yet the discourses of the refusal of work or techno-libidinal fantasies of liberation from work do not operate. What are particularly absent

are institutions and collective forms in which to engage the negation of work while considering the necessity and possibilities of sustainable existence. We encounter a capitalism that is, sometimes, quite happy to refuse us work while, at other times, to place extreme demands on us for work.

A working solution, to be deliberately ironic, is to struggle for decommodification of our lives. Campaigns against privatization and for the return of privatized services to public control try to reduce our dependence on work by attacking the way work is supposed to account for all of our self-reproduction. These struggles are in parallel for struggles to defend public services, protect benefits, and sustain social and collective forms of support. While they may be unglamorous, especially compared to space travel, these struggles can negate the conditions of the impossibility of work by trying to detach 'work' from its ideological and material role as the validation of citizenship and existence. In relation to the Nietzschean rebels of absolute communism or absolute acceleration these struggles can be dismissed as reactive, but they react precisely to the contradiction in which we are currently bound.

This is also true of the defence of workplace and employment conditions against new waves of privatization and outsourcing. The struggles at the University of Sussex over the outsourcing of support work, under much worse contracts and conditions, has forged an alliance of workers and students on the grounds of the precarity and impossibility of labor. It has also involved new experiments with forms and organizations against unresponsive unions and neoliberal management strategies. This impossibility of labor, I'm suggesting, does not simply mean abandoning work as an impossible site in the name of a dream of exit. Instead the negation of capitalist work can also be the struggle to free that true choice Timothy Brennan indicates by breaking our relation with constant 'accelerative' demand that we attend to the commodification of our lives.

People are Afraid to Merge

When Jean-François Lyotard invoked 'mechanical ascetism' he wrote of it as a 'new sensibility made up of little strange montages.'[13] This sensibility was explicitly one of full *jouissance* with Lyotard, as we saw, mocking the French who thought *jouissance* meant 'the euphoria that follows a meal washed down with Beaujolais.' The political sensibility underlying accelerationism is one of *jouissance*, taken to the extreme, and merged with the promise or fantasy of full immersion in the Real forces of acceleration. The attraction of this sensibility lies, as I've tracked, on this fantasy of immersion into Real forces, with a new acceleration always promised and always just out of reach. To adapt Sade, it's always 'one more effort, to truly be accelerationists'.

While explicit accelerationists remain fairly rare, the emphasis on a sensibility of acceleration and speed is much more widespread. From discussions of the 'resonance' of contemporary struggles to the spreading wildfire of communization, a range of disparate and often conflicting theoretical and activist positions converge on the need for speed. While these models don't adhere strictly in the accelerationist form of speeding-up capital or offer various forms of speeding-up of struggles (which often rely on the technological media of capital, such as Facebook), 'little strange montages' that integrate acceleration are everywhere.

This sensibility is one of flux and flow – in accelerationism the liquid is everywhere. At the same time a residual hardness, most evident in the early twentieth-century avant-gardes, still remains. The hardness is now the capacity to form strange montages without reserve, to fully immerse and so disperse into fluxes and flows. This is an aesthetics or practice of liquefaction that can temporarily solidify to activate force, before dispersing again into new liquid immanent forces.

From the classical accelerationist position any rejection of acceleration leads to a sensibility of what Nick Land calls 'transcendental miserablism.'[14] To give up on the dream of accel-

erating is to lapse into a Gnostic belief that the world is fallen into evil. Supposedly lacking any positive alternative the anti-accelerationist can only regard everything as negative and is left with only the feeling of resentment. Land's answer is 'Go (hard) for capitalism'. If we want to counter accelerationism, as I do, then we have to address how an alternative political sensibility might define itself not simply as a mode of misery.

The first point I'd make is that the immersive accelerationist makes a lot of their misery, but simply changed into *jouissance*. It is the accelerationist who risks constructing an absolute image of capitalism as monstrous machine or, in the case of Land, as the summoning of one of H.P. Lovecraft's monstrous Shoggoths.

The Shoggoth, which appears in Lovecraft's novella of Antarctic horror *At the Mountains of Madness* (1931), is an apt symbol for accelerationism. It is a creature that was genetically engineered as a 'beast of burden' to do the work for the Old Ones – ancient alien beings who inhabited the earth before humanity, and which were masters of occult knowledge. The Shoggoths developed a rudimentary intelligence and eventually rebelled, but were defeated by the Old Ones. A few remain and it is one of these creatures that is encountered at the climax of Lovecraft's narrative by his unlucky human explorers. This is how it appears to Lovecraft's unfortunate heroes:

the nightmare, plastic column of fetid black iridescence oozed tightly onward through its fifteen-foot sinus, gathering unholy speed and driving before it a spiral, rethickening cloud of the pallid abyss vapor. It was a terrible, indescribable thing vaster than any subway train – a shapeless congeries of protoplasmic bubbles, faintly self-luminous, and with myriads of temporary eyes forming and un-forming as pustules of greenish light all over the tunnel-filling front that bore down upon us.[15]

Capitalism, for the accelerationist, bears down on us as accelerative liquid monstrosity, capable of absorbing us and, for Land, *we must welcome this*. The history of slave labor and literally monstrous class struggle is occluded in the accelerationist invocation of the Shoggoth as liquid and accelerative dynamism. The horror involves a forgetting of class struggle (even in dubious fictional form) and the abolition of friction in the name of immersion.

The second point is that this desire for immersion and forgetting is, I'd suggest, generated out of the psychopathologies which capitalism induces. By now we are familiar enough with a litany of psychological maladies that have been claimed as the signature disorder of capitalism: psychopathy, narcissistic personality disorder, schizophrenia, depression, hysteria, anxiety, etc. In response to these psychic effects accelerationism responds by intensification to transcend the limit: schiz to the point of excess, the potency of depression, and the enjoyment of subjection. The pathological effects of contemporary capitalism barely need pointing out and are the lived experience of most of us. We all know what's wrong. Therefore, I don't think the task is to add or refine the relentless framing of capitalism as generator of negative experience or the mutilation of ourselves. To be called to merge with the capitalist Shoggoth is hardly useful... Instead, and what is much more difficult, is what we *do* with this basis of affects, experiences, and moods.

I want to suggest that the starting point of any political sensibility, by which I mean a sensibility from the left, is to break with fantasies of Real forces of acceleration. This fantasy consists of the premise of the existence of forces that promise accelerative vitality, even in the most extreme moments of despair. These are dispersed and plural forces, which allow for multiple possibilities of accelerationism that can change form or content. It is integration with these real forces that offers an immersive immediacy without any mediation or any fantasy, and abandons

the order of human language for the disorder of an inhuman existence.

What I'm arguing for is a restoration of the sense of friction that interrupts and disrupts the fundamental accelerationist fantasy of smooth integration. This smoothness is neatly summarized by a statement from one of the characters in another Lovecraft story 'The Whisperer in Darkness' (1931): 'All transitions are painless, and there is much to enjoy in a wholly mechanized state of sensation.'[16] The fact this line is spoken by a human whose brain has been removed and placed in a metal cylinder to allow for space travel indicates the 'transcosmic horror' disavowed by accelerationism. It's something to the credit of accelerationism that it doesn't tend to figure transitions as 'painless', but as sites of *jouissance*. The solution, however, to making the transition is 'going hard' to go soft, in a peculiar mixture of machismo and the valorization of feminised immersion.

I'm not suggesting a return to the human, or a simple decelerative equilibrium, withdrawal, or new asceticism, as an answer. Our task today is to collectively sustain forms of struggle and negation that do not offer false consolation, either of inbuilt hope or of cynicism and absolute despair. In terms of political sensibility this would mean neither relentlessly tracking pathologies nor celebrating their coming magical transformation into new powers. Starting from misery might instead involve developing forms of politicization that could not only recognize misery but delink from what causes us misery.

This strange montage would involve the recognition of the friction of integration, which isn't simply posed as an alternative of hard or soft, transcendent or immersive. Instead we are already up to our necks in potential and actual integrations, immersions, and extractions. The tension of these moments requires a collective sense of past struggles and of struggles to come, a recognition that the impossibility of work as it is has

been shaped not only by capitalism but also by resistance. It also involves attention to the aesthetics of these moments of friction, which encode the tension accelerationism wishes to dissolve. There is not much consolation or celebration to be found here, this is not as fun as the montage promised by accelerationism, but it is a place to start.

Notes

Preface

1. Hartmut Rosa, *Alienation and Acceleration: Towards a Critical Theory of Late-Modern Temporality* (Malmö: NSU Press, 2010), p.9.
2. Nick Land, *Fanged Noumena: Collected Writings 1987-2007*, intro. Ray Brassier and Robin Mackay (Falmouth: Urbanomic, 2013, e-book).
3. Benjamin Noys, *The Persistence of the Negative* (Edinburgh: Edinburgh University Press, 2010), pp.4–9.

Introduction

1. Gilles Deleuze and Félix Guattari, *Anti-Oedipus*, trans. Robert Hurley, Mark Seem, and Helen R. Lane (Minneapolis, MN: University of Minnesota Press, 1983), pp.239–40.
2. Friedrich Nietzsche, 'Letter to Jacob Burckhardt, Turin, January 1889', in *Selected Letters of Friedrich Nietzsche*, ed. and trans. Christopher Middleton (Indianapolis: Hackett, 1996), p.347 (trans. mod.).
3. Karl Marx and Friedrich Engels, 'Manifesto of the Communist Party' [1848], *Marxists Internet Archive* (2004): http://www.marxists.org/archive/marx/works/1848/communist-manifesto/
4. Jean-François Lyotard, *Libidinal Economy* [1974], trans. Iain Hamilton Grant (London: Athlone, 1993), p.214.
5. Jean- François Lyotard, *Peregrinations: Law, Form, Event* (New York: Columbia University Press, 1988), p.13.
6. Jean Baudrillard, *Symbolic Exchange and Death* [1976], trans. Iain Hamilton Grant, intro. Mike Gane (London: Sage, 1993), p.4.
7. Jean Baudrillard, *The Mirror of Production* [1973], trans. Mark Poster (New York: Telos Press, 1975), p.17.

8. Lyotard, *Libidinal Economy*, p.109.
9. Ibid., p.110.
10. Joseph Conrad, *Lord Jim* [1900], *Project Gutenberg*: http://www.gutenberg.org/etext/5658
11. Karl Marx, *The Poverty of Philosophy* [1847], *Marxists Internet Archive* (2009): http://www.marxists.org/archive/marx/works/download/pdf/Poverty-Philosophy.pdf
12. Karl Marx, 'Preface' to 'A Contribution to the Critique of Political Economy' [1859], *Marxists Internet Archive* (1999): http://www.marxists.org/archive/marx/works/1859/critique-pol-economy/preface.htm
13. Karl Marx, 'The Future Results of British Rule in India' [1853], in *Surveys from Exile*, ed. David Fernbach (Harmondsworth: Penguin, 1973), pp.319–325, p.323.
14. For a sympathetic discussion of Marx's arguments see Aijaz Ahmed, 'Marx on India: A Clarification', in *In Theory* (London: Verso, 2008), pp.221–242.
15. Marx and Engels, 'Manifesto'.
16. Karl Marx, *Grundrisse*, trans. Martin Nicolaus (London: Penguin, 1973), p.706.

Chapter I

1. In Lucy Hughes-Hallet, *The Pike: Gabriele D'Annunzio Poet, Seducer and Preacher of War* (London: Fourth Estate, 2013), p.11.
2. Paul Virilio, *Speed and Politics*, trans. Mark Polizzoti (New York: Semiotext(e), 1986), p.62.
3. Jonathan Crary, *24/7: Late Capitalism and the Ends of Sleep* (London and New York: Verso, 2013).
4. Marinetti in Lawrence Rainey, Christine Poggi, and Laura Wittman (eds.), *Futurism: An Anthology* (New Haven and London: Yale University Press, 2009), p.51.
5. Ibid., p.51.

6. Ibid., p.109.
7. Ibid., p.104.
8. Fredric Jameson, *Fables of Aggression: Wyndham Lewis, the Modernist as Fascist* [1979] (London: Verso, 2008), pp.81–2.
9. Rainey et al, *Futurism*, pp.298–301.
10. Ibid., 300.
11. Jeffrey T. Schnapp, 'The Statistical Sublime', in *The History of Futurism: The Precursors, Protagonists, and Legacies*, ed. Geert Buelens, Harald Hendrix, and Monica Jansen (Lanham: Lexington Books, 2012), pp.107–128.
12. Walter Benjamin, *Selected Writings, vol. 4 1938-1940*, ed. H. Eiland and M. W. Jennings (Cambridge, MA: Harvard University Press, 2003), p.270.
13. Walter Benjamin, *One-Way Street and Other Writings*, trans. Edmund Jephcott and Kingsley Shorter, London: New Left Books, 1979), p.103. Further page references in text.
14. Wyndham Lewis, *Blasting and Bombardiering: An Autobiography (1914-1926)* [1937] (London: John Calder, 1982), p.34.
15. Ibid.
16. Jean-François Lyotard, *Duchamp's Transformers* [1977] (Venice, CA: The Lapis Press, 1990), p.14. Further page references in text.
17. Virilio, *Speed and Politics*, p.119.
18. Rainey et al, *Futurism*, p.53.

Chapter 2

1. Robin Blackburn, 'Fin de Siècle: Socialism after the Crash', *New Left Review* I/185 (1991): 5–66, p.43 n.66.
2. Christopher J. Arthur, *The New Dialectic and Marx's Capital* (Leiden: Brill, 2004), p.201.
3. Susan Buck-Morss, *Dreamworlds and Catastrophe: The Passing of Utopia in East and West* (Cambridge, MA: The MIT Press, 2002), p.107.

4. Karl Marx, *Capital vol. 1*, intro. Ernest Mandel, trans. Ben Fowkes (Harmondsworth: Penguin, 1976), p.926.

5. Trotsky in Lars T. Lih, '"Our Position is in the Highest Degree Tragic": Bolshevik "Euphoria" in 1920', in *History and Revolution: Refuting Revisionism*, ed. Mike Haynes and Jim Wolfreys (London: Verso, 2007), p.118.

6. Ibid., p.121.

7. Ibid., p.128.

8. For an account of the experience of War Communism and the avant-garde, see T.J. Clark 'God is Not Cast Down', in *Farewell to an Idea* (New Haven and London: Yale University Press, 1999), pp.225–297.

9. V.I. Lenin, 'The Taylor System – Man's Enslavement by the Machine' [1913], *Marxists Internet Archive* (2004): http://www.marxists.org/archive/lenin/works/1914/mar/13.htm

10. Robert Linhart, *Lenine, les Paysans, Taylor* (Paris: Éditions du Seuil, 1976).

11. Buck-Morss, *Dreamworlds*, p.62.

12. Richard Stites, *Revolutionary dreams: utopian vision and experimental life in the Russian revolution* (Oxford: Oxford University Press, 1989), p.161.

13. Stites, *Revolutionary Dreams*, pp.149–55. See also Rolf Hellebust, *Flesh to Metal: Soviet Literature and the Alchemy of Revolution* (Ithaca and London: Cornell University Press, 2003), pp.45–54.

14. in Buck-Morss, *Dreamworlds*, p.297 n.16.

15. Stites, *Revolutionary Dreams*, p.150.

16. in Patricia Carden, 'Utopia and Anti-Utopia: Aleksei Gastev and Evgeny Zamyatin', *Russian Review* 46.1 (1987): 1–18, pp.7–8.

17. in Stites, *Revolutionary Dreams*, p.152.

18. Yevgeny Zamyatin, *We*, trans. Alexander Glinka (e-book, 2011).

19. in Rosa Ferré, 'Time is Accelerating', in *Red Cavalry: Creation and Power in Soviet Russia Between 1917 and 1945*, ed. Rosa Ferré (Madrid: La Casa Encendida, 2011), pp. 46–93, p.70.
20. Ibid., p.72.
21. Stites, *Revolutionary Dreams*, p.153.
22. Ibid., pp.226–7.
23. Slavoj Žižek, *Did Somebody Say Totalitarianism?: Four Interventions in the (Mis)Use of a Notion* (London: Verso, 2002), p.108.
24. in Hellebust, *Flesh to Metal*, p.172.
25. Andrei Platonov, *The Foundation Pit*, trans. Robert Chandler, Elizabeth Chandler and Olga Meerson (New York: NYRB Books, 2009), p.107.
26. Ibid., p.128.
27. Ibid., p.222.
28. in Stites, *Revolutionary Dreams*, p.225.
29. Kate Brown, 'Out of the Solitary Confinement: The History of the Gulag', *Kritika: Explorations in Russian and Eurasian History* 8:1 (2007): 67–103.
30. Karl Marx, 'The Production Process of Capital' [1861-3], *Marxists Internet Archive*: http://www.marxists.org/archive/marx/works/1861/economic/index.htm
31. Karl Marx, *The German Ideology* [1845], *Marxists Internet Archive*: http://www.marxists.org/archive/marx/works/1845/german-ideology/ch01a.htm
32. Arthur, *New Dialectic*, p.209.

Chapter 3

1. Nick Land, 'No Future' (1995), in *Fanged Noumena*.
2. in Paul Roazen, *Freud and his Followers* (Harmondsworth: Penguin, 1979), p.326.
3. Victor Tausk, *On the Origin of the Influencing Machine in*

Schizophrenia [1919], trans. Dorian Feigenbaum, Kindle Book (2011).

4. Gilles Deleuze and Félix Guattari, *Anti-Oedipus*, p.9.

5. Theodor Adorno, *Minima Moralia*, trans. Denis Redmond, *Marxists Internet Archive* (2005) #33: http://www.marxists.org/reference/archive/adorno/1951/mm/

6. Paul Virilio, *Speed and Politics*, p.75.

7. See Katherine Sharpe, 'I Heard Beauty Dying': The Cultural Critique of Plastic in *Gravity's Rainbow* (unpublished MA thesis, Cornell University, 2007): http://hdl.handle.net/1813/5906

8. Thomas Pynchon, *Gravity's Rainbow* [1973] (London: Picador, 1975), p.285; further page references in text.

9. Christian Kerslake, 'Rebirth through Incest: on Deleuze's early Jungianism', *Angelaki* 9.1 (2004): 135–157.

10. Thomas Pynchon, *V* (Philadelphia, PA: Bantam Books, 1963), p.210.

11. Jean Baudrillard, *The Transparency of Evil: Essays on Extreme Phenomena* [1990], trans. James Benedict (London: Verso, 1993), pp.113–123.

12. Theodor W. Adorno, *Quasi una Fantasia: Essays on Modern Music*, trans. Rodney Livingstone (London and New York: Verso, 1992), p.173.

Chapter 4

1. Alain Badiou, *The Century* [2005], trans., with commentary and notes, Alberto Toscano (Cambridge: Polity, 2007), pp.48–57.

2. Enda Duffy, *The Speed Handbook: Velocity, Pleasure, Modernism.* (Durham, NC: Duke University Press, 2009).

3. Fredric Jameson, 'In Soviet Arcadia', *New Left Review* 75 (2012): 119–127, p.125.

4. William Gibson, *Neuromancer* (London: Grafton, 1984):

http://lib.ru/GIBSON/neuromancer.txt

5. Ibid.

6. Joshua Clover, 'Remarks on Method', *Film Quarterly* 63.4 (2010): 7–9, p.9.

7. Michel Foucault, *The Birth of Biopolitics: Lectures at the Collège de France, 1978-79*, trans. Graham Burchell (Basingstoke: Palgrave, 2008), pp.224–5.

8. Dan Georgakas and Marvin Surkin, *Detroit: I Do Mind Dying* (Cambridge, MA: South End Press, 1998), p.85–106.

9. Kodwo Eshun, 'Further Considerations on Afrofuturism', CR: The New Centennial Review 3.2 (2003): 287–302, p.300.

10. R.L., 'Wanderings of the Slave: Black Life and Social Death', *Mute Magazine*, 5 June 2013: http://www.metamute.org/editorial/articles/wanderings-slave-black-life-and-social-death

11. Nick Land, 'Meat' (1995), in *Fanged Noumena*.

12. Nick Land, 'No Future' (1995), in *Fanged Noumena*.

13. Nick Land, 'Machinic Desire' (1993), in *Fanged Noumena*.

14. Immanuel Wallerstein, 'Braudel on Capitalism, or Everything Upside Down', *The Journal of Modern History* 63.2 (1991): 354–361.

15. Nick Land, 'Meltdown' (1997), in *Fanged Noumena*. See also a more recent text: Nick Land, 'China's Great Experimentalist', *Shanghai Star*, 2004: http://app1.chinadaily.com.cn/star/2004/0826/vo3-x.html

16. Nick Land, 'The Dark Enlightenment', 2014: http://www.thedarkenlightenment.com/the-dark-enlightenment-by-nick-land/

17. Karl Marx and Friedrich Engels, 'Manifesto of the Communist Party'.

18. Nick Land, 'Meltdown', in *Fanged Noumena*.

19. Nick Land, 'No Future', in *Fanged Noumena*.

20. Fredric Jameson, *Brecht and Method* (London: Verso, 1998), p.4.

21. Gopal Balakrishnan, 'Speculations on the Stationary State', *New Left Review* 59 (2009): 5–26, p.15.

22. Nick Srnicek and Alex Williams, 'On Cunning Automata: Financial Acceleration and the Limits of the Dromological', forthcoming in *Collapse* VIII (2013).

23. Karl Marx, *Capital Vol. III, Marxists Internet Archive* (1996): http://www.marxists.org/archive/marx/works/1894-c3/ ch15.htm

24. Virilio, *Speed and Politics*, p.134.

Chapter 5

1. Norman Cohn, *The Pursuit of the Millennium* (London: Paladin, 1970).

2. Guy Debord, *Society of the Spectacle* [1967], #138, *Marxists Internet Archive*: http://www.marxists.org/reference/archive/debord/society. htm

3. Franco 'Bifo' Berardi, 'Communism is back but we should call it the therapy of singularisation', *Generation Online* (2009): http://www.generation-online.org/p/fp_bifo6.htm

4. Melinda Cooper and Angela Mitropolous Angela, 'In Praise of Ursura', *Mute* vol. 2 #13 (2009): 92–107, p.107: http://www.metamute.org/editorial/articles/praise-usura

5. Antonio Negri, 'No New Deal is possible', trans. Arianna Bove, *Radical Philosophy* 155 (2009): 2–5.

6. Gopal Balakrishnan, 'Speculations', p.7 n.2.

7. Michael Heinrich, 'Crisis Theory, the Law of the Tendency of the Profit Rate to Fall, and Marx's Studies in the 1870s', *Monthly Review* 64.11 (2013): http://monthlyreview.org/2013/04/01/crisis-theory-the-law-of-the-tendency-of-the-profit-rate-to-fall-and-marxs-studies-in-the-1870s

8. Georg Lukács, *History and Class Consciousness*, trans. Rodney Livingstone (London: Merlin Press, 1971), p.181; further

page references in text.

9. Antonio Negri, *Books for Burning: Between Civil War and Democracy in 1970s Italy*, trans. ed. Timothy S. Murphy, trans. Arianna Bove, Ed Emery, Timothy S. Murphy and Francesca Novello (London and New York: Verso, 2005), p.27.

10. Ibid., p.27; my italics.

11. Michael Hardt and Antonio Negri, *Empire* (Cambridge, MA: Harvard University Press, 2000).

12. Alain Badiou, *Theory of the Subject* [1982], trans. and intro. Bruno Bosteels (London: Continuum, 2009), p.109; further page references in text.

13. Alain Badiou, *Polemics*, trans. and intro. Steve Corcoran (London: Verso, 2006), pp.44–5.

14. Paolo Virno, *A Grammar of the Multitude: For an Analysis of Contemporary Forms of Life*, trans. Isabella Bertolleti, James Cascaito and Andrea Casson, foreword by Sylvère Lotringer (Los Angeles and New York: Semiotext(e), 2005), pp.10–11.

15. Balakrishnan, 'Speculations', p.7 n.2.

16. Ibid., p.15.

17. Karl Marx, *The German Ideology*.

18. Balakrishnan, 'Speculations', p.16.

Chapter 6

1. Félix Guattari, *La revolution moléculaire* (Fontenay-sous-Bois: Editions Recherches, 1977), p.17.

2. Alain Badiou, *The Century*, p.45.

3. Georges Bataille, *Visions of Excess*, ed. and intro. Allan Stoekl (Minneapolis, MN: University of Minnesota Press, 1985), p.92; further page references in text.

4. Joseph A. Schumpeter, *Capitalism, Socialism and Democracy* (London: Routledge, 1994), pp.81–87.

5. Jean-Joseph Goux, 'General Economics and Postmodern Capitalism', *Yale French Studies* 78 (1990): 206–224.

6. Charles Fleming, *High Concept: Don Simpson and the*

Hollywood Culture of Excess (London: Bloomsbury, 1999).

7. Mike Davis, *Planet of Slums* (London and New York: Verso, 2006), pp.137–50.

8. Jean Baudrillard, *The Mirror of Production*.

9. Norman O. Brown, *Life against Death* (Middletown, CT: Wesleyan University Press, 1977), p.179.

10. Eli Zaretsky, 'Obituary: Norman O. Brown (1913-2002)', *Radical Philosophy* 118 (2003): 50–52: http://www.radicalphilosophy.com/obituary/norman-o-brown-1913%E2%80%932002

11. Kaja Silverman and Harun Farocki, *Speaking About Godard* (New York: New York University Press, 1998), pp.85–142.

12. Ibid., p.89.

13. Brian Henderson, 'Toward a Non-Bourgeois Camera Style', *Film Quarterly* 24.2 (1970-71): 2–14, p.2.

14. Jonathan Swift, 'The Lady's Dressing Room' (1732), ed. Jack Lynch: http://andromeda.rutgers.edu/~jlynch/Texts/dressing.html

15. Farocki, *Speaking*, p.91.

16. Jean-Luc Godard, *Weekend / Wind from the East* (London: Lorrimer Publishing, 1972), p.98.

17. Bataille, *Visions*, p.92.

18. Robin Wood, 'Godard and Weekend', in *Weekend*, pp.5–14, p.11.

19. Ibid., p.11–12.

20. in Richard Jeffries, *After London* (Oxford: Oxford University Press, 1980), p.viii.

21. Silverman, *Speaking*, p.96.

22. Ibid., p.111.

23. Thomas M. Kavanagh, 'Godard's Revolution: The Politics of Meta-Cinema', *Diacritics* 3.2 (1973): 49–56, p.52.

24. Christopher Williams, 'Politics and Production', *Screen* 12.4 (1971): 6–24, p.13.

25. Evan Calder Williams, 'Hostile Object Theory', *Mute* (2011): http://www.metamute.org/en/articles/hostile_object_theory

Chapter 7

1. Fredric Jameson, 'Dresden's Clocks', *New Left Review* 71 (2011): 141–152, p.150.
2. Walter Benjamin, *Selected Writings vol. 4*, p.402.
3. Ibid., p.393.
4. Walter Benjamin, *Selected Writings, vol. 2, part 2 1931-1934*, ed. Michael W. Jennings, Howard Eiland, and Gary Smith (Cambridge, MA: Harvard University Press, 1999), p.774.
5. Gershom Scholem, *Walter Benjamin: The Story of a Friendship* (New York: New York Review Books, 2003), p.202.
6. in Alain Badiou, *The Century*, p.45.
7. Ibid., p.45.
8. Ibid., p.45.
9. in Andreas Huyssen, *After the Great Divide: Modernism, Mass Culture, Postmodernism* (Bloomington, IN: Indiana University Press, 1986), p.229 n.6.
10. Benjamin, SW, vol. 2, part 2, p.733.
11. Walter Benjamin, 'Conversations with Brecht', *New Left Review* I/77 (1973): 51–57, p.56.
12. Benjamin, *SW vol. 2, part 2*, pp.541–542.
13. Irving Wohlfarth, 'No-Man's-Land: On Walter Benjamin's "Destructive Character"', *Diacritics* 8.2 (1978): 47–65, p.53.
14. Fredric Jameson, *Brecht and Method*, p.8.
15. Ibid., p.8.
16. Ibid., p.149; my italics.
17. Bertolt Brecht, *Short Stories 1921-1946*, ed. John Willett and Ralph Manheim (London: Methuen, 1983), pp.77–85; further page references in text.
18. Benjamin, *SW vol. 2, part 2*, p.734.
19. Ibid., pp.733–34.
20. Benjamin, *SW vol. 2, part 2*, 563–568.
21. Walter Benjamin, *One-Way Street*, p.358.
22. William Topaz McGonagall, 'The Tay Bridge Disaster', *McGonagall Online*:

http://www.mcgonagall-online.org.uk/gems/the-tay-bridge-disaster

23. Benjamin, *SW vol. 2, part 2*, p.567.
24. Benjamin, *One-Way Street*, p.358.
25. Ibid., p.358.
26. Ibid., p.232.
27. Benjamin, *SW vol. 4*, p.402.
28. Ibid., p.402.
29. Ibid., p.392.
30. Benjamin, *One-Way Street*, p.238.
31. Ibid., p.239.

Conclusion

1. V.I. Lenin, 'Left-Wing Communism: an Infantile Disorder' [1920], *Marxists Internet Archive* (1999): https://www.marxists.org/archive/lenin/works/1920/lwc/
2. Franco 'Bifo' Berardi, *After the Future*, ed. Gary Genosko and Nicholas Thorburn, (Oakland, CA: AK Press, 2011), p.138.
3. Timothy Brennan, *Secular Devotion: Afro-Latin Music and Imperial Jazz* (London and New York: Verso, 2008), p.167.
4. Ibid., pp. 167–8.
5. Srnicek and Williams, 'On Cunning Automata'.
6. Nick Srnicek and Alex Williams, '#Accelerate: Manifesto for an Accelerationist Politics', in *Dark Trajectories: Politics of the Outside*, ed. Joshua Johnson (Hong Kong: [Name] Publications, 2013), pp.135–155, p.140.
7. Ibid., p.140.
8. Srnicek and Williams, 'On Cunning Automata'.
9. Ibid.
10. Adorno, *Minima Moralia*, #100.
11. Alex Williams, 'Back to the Future? Technopolitics and the Legacy of the CCRU', 'The Death of Rave' event, Berlin, 1 February 2013: http://www.electronicbeats.net/en/radio/eb-listening/the-

death-of-rave-panel-discussions-from-ctm-13/

12. Franco Barchiesi, *Precarious Liberation: Workers, the State, and Contested Social Citizenship in Postapartheid South Africa* (New York: SUNY Press, 2011).
13. Lyotard, *Duchamp's Transformers*, p.15.
14. Nick Land, 'Critique of Transcendental Miserablism', in *Fanged Noumena*.
15. H.P. Lovecraft, *At the Mountains of Madness* [1931], *Dagonbytes.com*:
 http://www.dagonbytes.com/thelibrary/lovecraft/mountainsofmaddness.htm
16. H.P. Lovecraft, 'The Whisperer in Darkness' [1931], *Dagonbytes.com*:
 http://www.dagonbytes.com/thelibrary/lovecraft/thewhispererindarkness.htm

Contemporary culture has eliminated both the concept of the public and the figure of the intellectual. Former public spaces – both physical and cultural – are now either derelict or colonized by advertising. A cretinous anti-intellectualism presides, cheered by expensively educated hacks in the pay of multinational corporations who reassure their bored readers that there is no need to rouse themselves from their interpassive stupor. The informal censorship internalized and propagated by the cultural workers of late capitalism generates a banal conformity that the propaganda chiefs of Stalinism could only ever have dreamt of imposing. Zer0 Books knows that another kind of discourse – intellectual without being academic, popular without being populist – is not only possible: it is already flourishing, in the regions beyond the striplit malls of so-called mass media and the neurotically bureaucratic halls of the academy. Zer0 is committed to the idea of publishing as a making public of the intellectual. It is convinced that in the unthinking, blandly consensual culture in which we live, critical and engaged theoretical reflection is more important than ever before.